Taking Refuge in L.A.

Life in a Vietnamese Buddhist Temple

春去百花落
春到百花開
事逐眼前過
老從頭上來
莫謂春殘花落盡
庭前昨夜一枝梅
　—滿覺禪師—

Spring goes leaving a hundred fallen flowers;
Spring arrives with a hundred new blooms.
Things pass away before our eyes;
Old age shows upon our heads.
　　Don't think spring ends and all flowers fall;
　　Last night in the garden, a branch of plum blossomed
　　　　　　—Ven. Măn-Giác (11th century)

Taking Refuge in L.A.

Life in a Vietnamese Buddhist Temple

Photographs by
Don Farber

Text by
Rick Fields

Introduction by
Thich Nhat Hanh

An Aperture Book

Designed and edited by Don Farber.

The Staff at Aperture for *Taking Refuge in L.A.: Life in a
Vietnamese Buddhist Temple*: Michael Hoffman, Executive
Director; Donald Young, Managing Editor; Stevan Baron,
Production Director; Barbara Sadick, Production Manager.

This book is published in conjunction with exhibitions at the
Pacific Asia Museum, Pasadena; The Asia Society, New York
City; and the Santa Barbara Museum of Art.

This project is sponsored by the International Rescue
Committee and is supported in part by the California Council
for the Humanities, a state program of the National
Endowment for the Humanities, and Shirley Burden. The
findings, conclusions, and opinions presented herein do not
necessarily represent the views of either the California Council
for the Humanities or the National Endowment for the
Humanities.

Composition by Wilsted and Taylor, Oakland.
Printed in Hong Kong by South China Printing Co.

Library of Congress Catalog Card Number: 87-070716
ISBN 89381-261-7.

Aperture Foundation, Inc. publishes a periodical, books, and
portfolios of fine photography to communicate with serious
photographers and creative people everywhere. A complete
catalog is available upon request. Address: Aperture, 20 East 23
Street, New York City, New York 10010.

Walking down Berendo Street, approaching Ninth, I saw a group of refugees in front of an old apartment building. The way they were standing there, leaning against cars and railings, reminded me of photographs I'd seen of Vietnam. It was January 1977, a little more than a year after the end of the Vietnam War, and I was visiting the Vietnamese Buddhist Temple for the first time.

As I walked up the steps and went through the Oriental gateway into the courtyard, I saw a barber giving a haircut, children running around, and Buddhist monks and nuns going up the stairs into the temple. Inside, people of all ages were sitting on the carpeted floor chanting together. From that first visit on, I was deeply moved by these people and their way of life. Their love and caring was an inspiration to me.

I first heard of the temple while working for a school media center collecting educational materials for the newly arrived refugee children. I remembered meeting the Vietnamese Zen master Thich Thien-An, and I thought he would be a good person to contact. He invited me to come to the temple on the following Sunday.

I went there that day without any intention of photographing, but I was so taken by what I saw that I ended up shooting a roll of film. Later, after looking at the proof sheet, I knew I had a project. I made a ritual of coming to the temple every Sunday to photograph and take part in the chanting ceremonies, and I began practicing Zen meditation with Dr. Thien-An.

My concern for the Vietnamese people goes back to 1963, when I, like so many others, was deeply affected by the pictures of Buddhist monks setting themselves on fire to protest the imprisonment by the Diem regime of hundreds of religious leaders. When I met Dr. Thien-An, I learned that his father was one of those monks.

Before coming to the United States, Dr. Thien-An had established himself as a highly regarded Buddhist master and scholar. In Japan, he became the first person in twenty years to receive a doctorate in literature from Waseda University, and when he returned to Vietnam, he co-founded Van Hanh University.

He arrived here in 1966, and in 1970 he established the International Buddhist Meditation Center in the Wilshire District of Los Angeles. A group of houses on New Hampshire Avenue was converted into a live-

in meditation community made up mostly of Americans. Within the same buildings, Dr. Thien-An also founded the University of Oriental Studies. He was one of the key people to introduce Buddhism to the West—touching the lives of thousands of Americans through the Meditation Center, as a teacher at Los Angeles City College, and with his books, *Zen Philosophy, Zen Practice*, and *Zen and Buddhism in Vietnam*.

When the war ended in 1975, Dr. Thien-An went to Camp Pendleton and brought back to the center three hundred of the refugees. Soon after, an old apartment building a block away on Berendo Street became the Vietnamese Buddhist Temple. As Supreme Abbot for the Vietnamese Buddhists in North America, Dr. Thien-An helped establish Vietnamese temples throughout the United States.

In the late seventies, when the boat people were escaping Vietnam in large numbers, the Vietnamese Buddhist Temple became a major stop-off point for many of the new arrivals. One of those who arrived here in 1978 was Dr. Thien-An's best friend, Dr. Thich Man Giac. They had known each other as young boys living in monasteries, as students in Japan where Dr. Man Giac also received a Ph.D. degree, and as college professors in Vietnam. The few years they spent together in Los Angeles were very special, but it wasn't to last.

Dr. Thien-An developed cancer, and on November 23, 1980, he died at the age of fifty-five.

It took a long time for the community to recover from the loss, but under the guidance of Dr. Man Giac, who succeeded Dr. Thien-An, the beautiful way of life at the temple continues.

A tragic situation in Vietnam, however, is constantly on the minds of the refugees here. The oppression of Buddhists that began during the French occupation is being continued by the current government. Top Buddhist leaders have been imprisoned as part of an effort to crush the Buddhists' popular support. In response, the refugees have initiated a letter-writing campaign to try to persuade the Vietnamese government to free these highly revered monks.

In sharing this view of the refugees in Los Angeles, my hope is that people will gain a new awareness of the Vietnamese. During the war, we knew them only as they were presented in the media. Rarely could we feel close to them. They were portrayed mostly as "guerrillas," napalm victims, or body counts. We rarely saw the richness of their culture and the real human qualities of the people. To reveal this has been my goal.

Don Farber

Dear Don—I have looked at the pictures attentively and I thank you for having sent them over. They are beautiful and inspiring. I hope many people will have a chance to look at them and to meditate upon the situation where all of us find ourselves now.

I do not know how much happiness the people of Vietnam have gotten from the importation of Western civilization to their country, but I know that the amount of suffering they have endured in the past few decades has been beyond measure. You know that the ideological conflict which has torn their country apart is not really their own. It was invented in the West and introduced from the West. Both capitalism and communism are alien to their way of life, yet they have taken the conflict to be their own and learned to look at each other as enemies. The weapons they have used to destroy each other and destroy their land have also been imported from the West. Their land and their people were divided and the world was behind them, taking sides and sharing "solidarity." Even if they wanted to stop, they could not. There was a time when a number of them tried to cry out, "Leave us alone so that we can settle the problem by ourselves." Their cry was lost in the sound of bombs. There was one time when they brought their family ancestral altars down to the streets to block the tanks. This attempt to challenge violence by their own traditional culture was not even understood. It looked as if their country was born to be crucified. For the world's sake? I do not know. Has humankind learned anything from their suffering? I do not know.

"Ga mot nha boi mat da nhau"—"In order to fight each other, the chicks born from the same mother hen put colors on their faces." This is a very well-known Vietnamese saying. Putting colors on one's own face is to make oneself a stranger vis-à-vis one's own brothers and sisters. And one could only shoot at the others when the others are strangers.

The conflict did not end after 1975. Anger, hatred, and retaliation continue. Perhaps you have learned that the boat people refugees in Hong Kong divided themselves into two camps, northern and southern, and continue to fight the war. Most Vietnamese living abroad, still considering themselves either pro-communist or anti-communist, continue the fight with magazine articles. They bring up their children

in this spirit of division and hatred, perpetuating the conflict into the future. When shall our heart be liberated from the bitterness? When will the chicks of the same mother hen get rid of the colors on their faces and recognize each other as brothers and sisters? If you knew how much suffering there has been, you would know how difficult it is to get rid of the bitterness.

Vietnam *is* the world and the suffering of Vietnam *is* the suffering of the world. We should be able to recognize this. No one in the world could say that he or she is not responsible. Our world continues to be Vietnam. On the body of the earth, we feel many painful spots like Vietnam. The cause of the suffering is the same. The conflict that has been causing so much suffering has also brought about means for mankind to destroy itself and the world: the nuclear arms race seems to be a cancer in the body of the world that can no longer be removed.

Let us look at each person in the pictures. Children, adults, and aged people. We find innocence, joy, serenity, but we also find loneliness, bitterness, and silent pain. Many people like them have died during the war, many have died in the ocean as boat people, many are still dying in reeducation camps. Look at them. Meditate on them. Their presence among the American people should create an awareness of what America has done and is doing. The conflict has not ended. Most of us still have colors on our faces. Most of us are still in the conflict. And the conflict is going to destroy us.

The only way out of the danger is for each of us to remove the colors from our faces. Each of us should be able to say to the others: I am your brother. I am your sister. Please recognize me as your brother, please recognize me as your sister. We are all of the human kind and our life is one. I know that we shall live or die together. I am capable of recognizing you, even under the colors that smear your face.

The pictures you take of the Vietnamese refugees, Don, should help in creating that awareness. Each member of the human race, whether he/she is African, European, or American, *is* the Vietnamese. The conflict is leading to the destruction of our own planet. When the destruction comes, where shall we be able to seek refuge, even if with our technology we become "space people" instead of "boat people"?

<div align="right">Nhat Hanh</div>

8

Taking Refuge in L.A.

Text by Rick Fields

It's a Sunday morning in Los Angeles, any Sunday, and people have started to drift into the temple on the corner of Berendo and Ninth streets. The monks who live there have been up since dawn or before, women have been cooking in preparation for lunch, and the children are playing in the courtyard. From a loudspeaker that can be heard more than a block away comes a lilting chant in a language the neighbors—Anglos, Hispanics, Koreans—have come to recognize as Vietnamese.

The chant is part of the Buddhist service that takes place every Sunday at Chua Viet-Nam, the Vietnamese Buddhist temple that serves as headquarters of the Vietnamese Buddhist tradition in the United States. The temple, which was converted from an old apartment building, is a few miles from downtown Los Angeles, in the area now known as Koreatown. The neighborhood is a polyglot of Latin Americans, Koreans, Anglos, Thais, and Vietnamese. The people who regularly come to Chua Viet-Nam live throughout Los Angeles and Orange counties—an area with an estimated one hundred seventy thousand Vietnamese. There are also eighteen smaller Buddhist temples in this area—and more than eighty throughout the United States, all of which were established after the fall of Saigon in 1975.

Though roughly half the Vietnamese in America are Buddhists (the other half are Catholic), Buddhists in Vietnam comprise about 80 percent of the population. Buddhism is a religion, philosophy, and a spiritual practice—a way of life—which the Vietnamese share with the Sinhalese, Japanese, Burmese, Koreans, and Tibetans, as well as with their neighbors, the Chinese, Cambodians, Thais, and Laotians. And now to their surprise, they find themselves sharing their Buddhism with a small but growing number of Americans who have also taken refuge in the Three Jewels—the Buddha, the Dharma (the teaching of the Buddha), and the Sangha (the community, both of monks and nuns, and of laypeople.)

The temple building is a U-shape two-story structure around an open courtyard, with the open end facing the street. At the end of the courtyard—the place you would reach if you just happened to walk in from the street out of curiosity—stands a larger-than-life statue of Quan-Am ("Kuan Yin" in

9

Chinese, "Kwannon" in Japanese), the bodhisattva of compassion, shining white, holding a lotus, smiling gently at the visitor and the street and world beyond. Quan-Am holds a jar, turned down toward the person who stands before her, pouring out—though it is not visible to the purely rational eye—what the Buddhists call *amrita*, or the water of compassion.

At the base of Quan-Am is an incense holder and, underneath that, a box with a slot for donations. Large sticks of incense lie to the side. The first and most natural thing to do, then, on entering or leaving the temple is to offer incense to the bodhisattva of compassion.

A flight of steps covered with a well-worn bright green carpet of the Astroturf type leads up to the second story, to a narrow balcony overlooking the courtyard and to a place to leave shoes. The wall behind the balcony contains a window in the form of the eight-spoked wheel that symbolizes the Buddhist Eight-fold Path.

The shrine room occupies the space at the top of the U. It is elaborate and colorful, in the Chinese manner. The central shrine holds a large gold representation of the Buddha sitting in meditation. Just beneath that is an exquisite small jade-green Buddha from Thailand, the gift of a visiting member of the Thai royal family. The head of the large Buddha image is haloed with concentric circles of neon—white, blue, red, yellow—that are continually ablaze.

There are two large side shrines—one for a protector in the Chinese warlord style, the other for Quan-Am. On either side of these shrines is a large pagodalike tower inset with hundreds of small sitting Buddhas. White elephants, symbols of good fortune, flank the main shrine.

To the left, at the end of the side room that also serves as a sitting room and as a passage to the kitchen and the dining room, is a large memorial shrine. The main image here is an ink painting of a glowering beetle-browed Bodhidharma—the legendary Indian monk who brought Zen to China—a gift from the Korean Zen master Sahn Sunim. Then there are hundreds of photographs of temple members and relatives who have died—so many that the photographs now must be made smaller so that all can fit.

This shrine also commemorates the past struggles of the Vietnamese Buddhists. To one side is a large

oil painting of the Venerable Thich Quang Duc, sitting in meditation, his robes in flames. Portraits of the first seven monks to immolate themselves during the Vietnam War are superimposed on a background of the Buddhist flag. Portraits of Vietnamese Buddhist leaders who have died in prison since the end of the war and of Dr. Thich Thien-An, the temple's late founder, are prominently displayed. ("Thich," which comes from the Buddha's family name, "Sakya," is used by all Vietnamese monks and nuns.)

The man most responsible for the temple—and for the temple's being in this particular place—had come to America to teach Americans Buddhism. Dr. Thien-An had arrived in the States in 1966 as a visiting professor at the University of California, Los Angeles. A scholar of formidable credentials, he had received his Ph.D. in Oriental literature from Japan's prestigious Wasada University.

He was also a Zen master in the Lam-Te ("*Lin-chi*" in Chinese, "*Rinzai*" in Japanese) school of Zen, which had originated in China. When a number of his students and friends, immigration papers in hand, asked him to stay and teach the Dharma in America, he acquiesced. Like a number of other Asian teachers of Buddhism who have taught in America, Dr. Thien-An wanted to build a bridge between East and West.

At that time, of course, neither he nor anyone else had any idea that more than a hundred thousand Vietnamese refugees would come to America after the fall of Saigon—or that in Vietnam Buddhists would be singled out for hardship, prison, and "reeducation" by the victorious North Vietnamese. He was not, in any case, hopeful about the future of Vietnam, and he also felt that Buddhism was losing its vitality in the East.

Dr. Thien-An founded the International Buddhist Meditation Center in an old wooden house on New Hampshire Avenue just west of Vermont Avenue and north of Olympic Boulevard. Shortly thereafter, he founded the College (later University) of Oriental Studies, which soon became a center for Buddhists of all schools and nationalities.

Dr. Thien-An would have been perfectly happy to continue teaching Buddhism to Westerners

through the Meditation Center and the University of Oriental Studies, but in 1975 Saigon fell and Dr. Thien-An, who in 1963 had been jailed by the pro-Catholic Diem government along with other leading Buddhists, found himself swept up once more in the suffering of the Vietnamese people. One of his American students remembers sitting with him and watching the eleven-o'clock news, with its footage of Americans fleeing the embassy compound in Saigon by helicopter while Vietnamese, desperate to leave before the Communists arrived, clawed at the embassy fence. "He would just sit quietly in absolute silence, watching. He never talked about it, but I could tell the suffering he was going through about his country."

After that, the phone never stopped ringing. Dr. Thien-An accepted collect calls from all over the world until the phone bill soared beyond the Center's capacity. He had become an American citizen, and he was the only Vietnamese monk of any prominence living in the United States, so it was natural for the government to ask for his help in resettling the Vietnamese refugees who were beginning to pour into America.

Dr. Thien-An had ordained a number of Americans as Buddhist monks and nuns. Some had taken the vows of celibacy that Chinese and Vietnamese Buddhist monks took, while others followed the Japanese model of leading a family life and wearing robes when at the Center. Dr. Thien-An compared this latter group to Protestant ministers, and felt that their work was particularly important for the spread of Buddhism in the West.

When the first planeloads of Vietnamese refugees arrived at Camp Pendleton after the fall of Saigon, they were met not only by Dr. Thien-An but by a small though visible group of American Buddhist monks and nuns. One of these, the American nun Reverend Karuna Dharma, says, "When those refugees came in, they expected to come to a country where there was no Buddhism, and so all that some of these people brought with them were sutras and maybe a change of clothes. We held Buddhist ceremonies right across from the processing center in Camp Pendleton, and as soon as they could break away they came running over because they had seen Americans in Buddhist robes, and those people would just

12

grab hold of you and weep openly because they'd found Buddhists in this country."

Dr. Thien-An had been putting all his energy into his work with American Buddhists, but he now seemed to draw on some unseen reserve in order to help the refugees. At first, many of them slept on the floors of the university buildings. Soon, however, Dr. Thien-An raised funds to buy apartment buildings to house the refugees. He took one building, at the corner of Ninth and Berendo just a block from the International Buddhist Meditation Center, and had it painted yellow ochre—the color of Buddhist robes—and turned it into a temple.

A Retreat at the Temple

It was in this building that I attended a weekend retreat in the winter of 1984. The retreat is observed once a month by a lay group, most of whom are women.

Having arrived in Los Angeles the day before, I was feeling harried and had rushed into the all-purpose waiting room and office adjacent to the main shrine. A grandmotherly-looking woman, her gray hair pulled back in a bun, wearing the light gray loose pants and shirt common to all the participants, took one look at me and said, "Hey, take it easy. You're in the temple now."

This "take it easy" became something of a touchstone for me, like a koan or mantra, during the retreat and after. Just as crucial was the capping phrase "You're in the temple now," for the temple, which stands on a corner of a busy intersection in Los Angeles, is a place of refuge—but one that is open, both literally and figuratively, to the world outside.

The ceremony inaugurating the retreat would be postponed, my friend told me, because a wedding was about to be performed. Looking from the balcony into the courtyard, I could see the wedding party assemble. A young Vietnamese woman wore the national costume—loose, flowing white trousers and a tunic (in this case there were two, an elaborately embroidered one and a transparent white gauze one with gold appliqué)—and a gold hat, shaped something like a crown, on her black hair. Her husband-to-be wore a tuxedo. The brief ceremony before the main shrine was conducted by a monk. The

reception was held in a room on the first floor of the temple.

None of the women waiting for the retreat to begin seemed perturbed by the delay. "We Buddhists, we got to take it easy, you know," my friend whispered to me as the wedding ceremony ended and the party went down to the room where the wedding reception would take place. "We got to be patient."

The retreat began with a ceremony in which the participants took a number of vows for the next twenty-four hours: no killing, lying, stealing, sexual misconduct; no using perfume or jewelry; no sitting or sleeping in "high places"; and no defaming the Three Jewels. No sitting or sleeping in high places was taken literally. The participants stayed close to the ground: we sat on the floor, and did not use chairs during breaks. At night, we all rolled out the sleeping bags we had brought and slept on the temple floor.

Most of the time was spent chanting. Buddhist chanting in general is monochromatic and syllabic—a style which derives from that of the early Indian Buddhists—but Vietnamese chanting is especially sweet and tuneful. It is high and slow and has a quality of melancholy or longing. It is accompanied by the traditional Buddhist percussion instruments: a bass drum, the wooden fish (mokyo), and bells, some small and high pitched, some low and echoing.

At noon, a monk slowly struck the large bell in the main shrine room as a signal that the Sunday service was about to begin. By the time the bell ringing had ceased—the deep clear sound fading off into emptiness with a sweet ever diminishing echo—the carpeted hall filled with people sitting on the floor or kneeling. Children too young to be with the Buddhist youth group downstairs wandered in and out.

Dr. Man Giac and nine monks in bright yellow robes entered and stood in front of the main shrine where there is a

14

Vietnamese Zen Patriarch Thich Man Giac with pigeons and doves that were bought in cages and then released during a traditional Buddhist ceremony as an expression of compassion for all living beings.

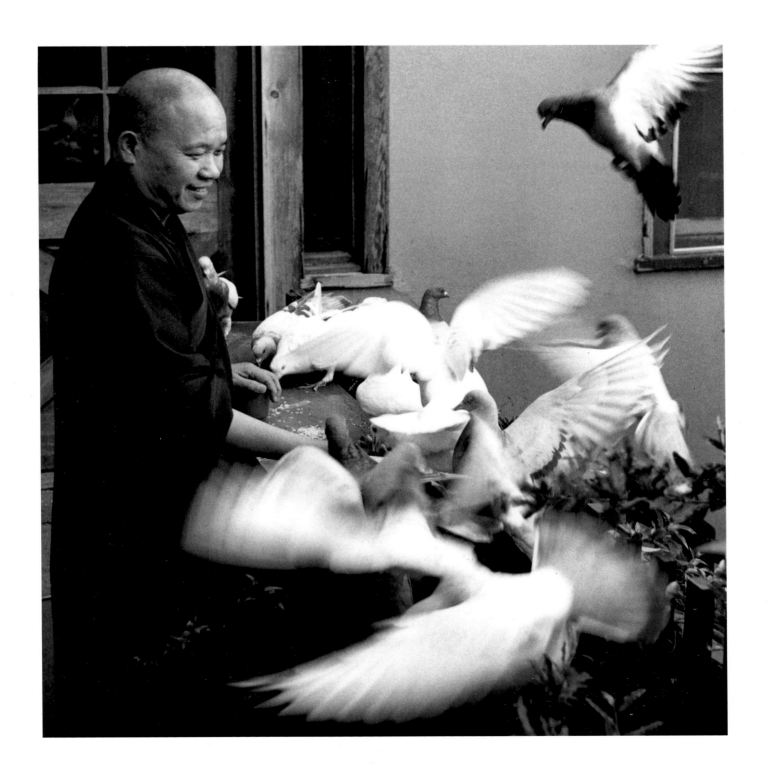

large seated Buddha with a painted backdrop. The painting is of the Bodhi Tree which the Buddha sat beneath for the meditation which led to his enlightenment, and of the surrounding countryside—forests and mountains fading into the distance. The service consisted largely of chanting and bowing—the chanting punctuated by prostrations in the Chinese style.

We took lunch sitting on the floor in front of the memorial shrine in the side room. Everyone was supplied with chopsticks and a small bowl of rice. The rest of the food was placed in bowls at the center of the table—common dishes from which everyone would take morsels with the chopsticks to mix in with the rice.

A short rest period followed the meal. Some people worked around the temple; others seemed to be catching up on the latest news, and some sat silently in the shrine room, meditating in the Zen style or reciting mantras with the aid of a mala, or rosary. When we resumed chanting, I discovered that I could make out the words in the liturgy book. By looking at the script, and with considerable help from the person next to me, and by listening to the chanting around me, I was able to chant along, more or less. This was apparently so unusual that some of the women were convinced that I was able to speak Vietnamese.

At about four, as the sun was sinking red and smokey over downtown L.A., a small altar was set up on the balcony and heaped with offerings and incense. Two candles flickered and flared in the late afternoon breeze.

The shrine, I was told, was for "the dead with no home"— the hungry ghosts, or *pretas*. We all turned, kneeling toward the shrine, and chanted to the sound of a high clear bell, and for a moment I could imagine all the hungry ghosts in Los Angeles making their way to our feast offering. "These

16

In Asian cultures, elderly people are respected for their age and experience and are well taken care of by their families and community. The closeness between the young and the old is one of the keys to why the temple is so lively and, at the same time, a place of concentrated spiritual practice.

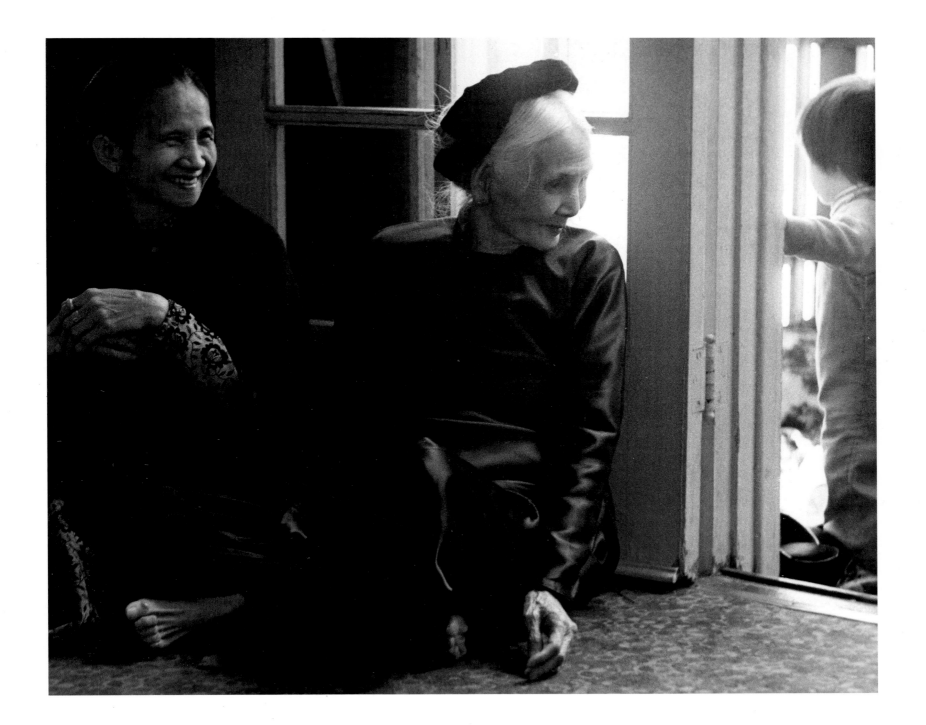

ghosts," one woman explained to me, "they have, you know, no family."

Upstairs, the adults had gathered for a memorial service for Henry Cabot Lodge, the former ambassador to South Vietnam. At the foot of the shrine, just above the offerings of oranges and other food and of flowers, was a large picture, blown up from a newspaper photograph of Lodge, who had died the day before. Seeing this photograph so prominently displayed was a vivid reminder of the tangled karmic ties between our two countries.

The room could not hold everybody, and the crowd spilled out onto the balcony. Just after the service, a visiting monk from a temple in Orange County gave a Dharma talk to about fifty people. Then Gary Snyder, who was giving a workshop for members of the Buddhist Peace Fellowship in one of the temple meeting rooms that afternoon, spoke through interpreter Jenny Hoang to the Vietnamese.

"For many years, I was the only Buddhist I knew," Gary Snyder said, and somebody tried, not very successfully, to quiet the shouts of the kids from the courtyard below. "In the years since then, there are more and more American Buddhists. We are your younger brothers and sisters, and we are really glad you have come with your deep culture and practice. . . . I'm grateful and optimistic that the compassionate and correct teachings of the Buddha are going to spread through the country. If it takes a long time, let it take a long time. It will make America a better place to live."

There was applause, and then everybody adjourned to the kitchen and dining room for a big lunch.

A few days later, on the night of the full moon, I joined about thirty people doing a hundred and eight prostrations while chanting the names of the Buddha. One side of the room stood and chanted while the other side prostrated, and

The Vietnamese Buddhist Youth Group, known as Long Hoa, *on the front steps of the temple. "We want members of Long Hoa,"* says one of their leaders, Nguyen Hanh, *"to become good citizens, to be able to help others, not just themselves. We had this group in Vietnam, we don't want it to end. When the children grow up, we want them to know who they are, to be good Buddhists. We don't want to forget that we are Vietnamese. We want to remember our culture."*

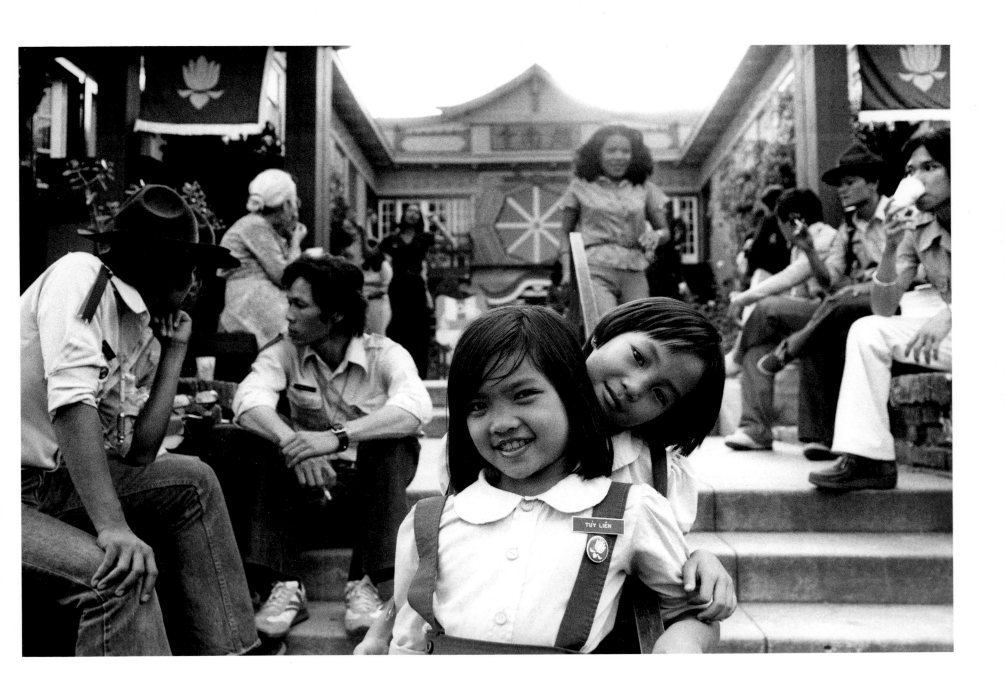

then vice versa, so that the chanting and bowing rose and fell back and forth. Next to me were a girl of about sixteen and her younger brother. After the service, I asked her if she had gotten involved in Buddhism in America or back in Vietnam. She looked a little puzzled by the question.

"Oh," she said, "in Vietnam my grandmother used to take me with her to the temple every Wednesday night."

"And now?" I asked.

"And now," she said, "she still does. That's her right over there, the one ringing the bells."

I left L.A. as I had come—in a hurry. There seemed hardly any time to pack, fight the freeway traffic, return the rented car, pick up the ticket, and so on. But I did find the time—a few minutes, no more—to stop by the temple and offer a stick of incense before the white statue of Quan-Am in the courtyard. I had to stop for a moment, to bow and to light the incense, and as I did I could hear, or thought I could hear, somebody reminding me, "Hey, take it easy. We Buddhists got to take it easy, you know."

The History

Buddhism teaches that suffering—*dukha*, or "unsatisfactoriness," in Sanskrit—is caused by our mistaken attachment to the notion of a separate, permanent self. Still, there are degrees of suffering, and a look at Vietnamese history leaves the impression that the Vietnamese have had a larger share of it than most.

The first Vietnamese emperor in written history appears in the Chinese annals, which note that in 208 B.C. a Chinese general conquered part of northern Vietnam and then proclaimed himself emperor of Nam Viet. Though the Vietnamese adopted much of Chinese culture—systems of rice cultivation, Chinese writing, and Buddhism and Confucian-

20

Members of the youth group rehearse for an annual performance held in a theater in downtown Los Angeles. These variety shows are popular with the Vietnamese community and usually last for about four hours. They include traditional dance, music, and comedy routines as well as guest appearances by singers and musicians who are well known in Vietnam.

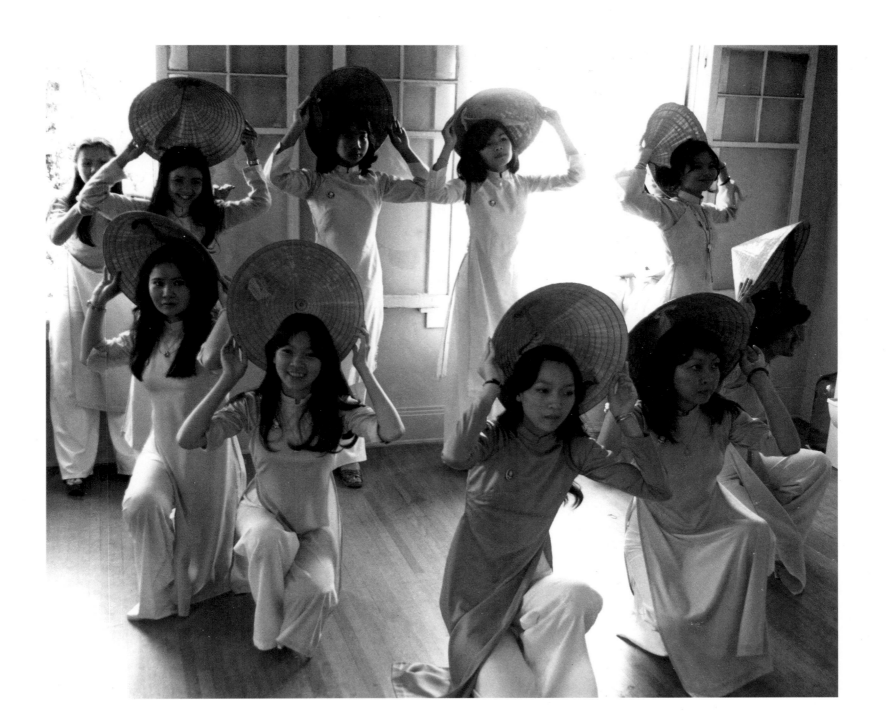

ism—they resisted China's continued attempts to assimilate them. They also fought and ultimately defeated the Mongol troops of Kublai Khan in the thirteenth century.

Buddhism has been woven into the fabric of Vietnamese culture since the first century, when Indian merchants and missionaries arrived by sea en route to China. A second-century account of "Buddhist monks who shaved their heads, wore the saffron-colored robe, ate once a day, and guarded their senses" suggests that the earliest Vietnamese Buddhists may have been influenced by the Theravadin, or School of the Elders, which flourished in neighboring Cambodia, Laos, and Thailand and in Sri Lanka. Though this form of Buddhism continued to influence the Vietnamese to some extent, it was the Mahayana—particularly the Zen ("Thien" in Vietnamese) and Pure Land schools from China—that came to exert the greatest influence on Vietnamese Buddhism.

According to Thich Thien-An's *Buddhism & Zen in Vietnam*: "The beginning of Buddhism as the national religion of the Vietnamese can be placed as early as the Dinh dynasty (969–981) when the ruling monarch Dinh-Bo-Linh established a Vietnamese Sangha and initiated the practice of appointing eminent monks to serve as royal advisers on political, religious, and domestic matters."

The first Zen school to take root in Vietnam was brought to the country by Vinitaruci, a monk from western India. He had gone to China from India in A.D. 574, and received transmission of the teaching from the great Zen master Seng-ts'an, the third Patriarch of the Zen tradition of China, whose Taoist-flavored *Verses on the Heart Poem* are still revered by Zen students today.

The next major Zen school to enter Vietnam from China was brought by the Venerable Vo-Ngon-Thong. When he went off to T'ang-dynasty China to seek enlightenment, he

22

The game called Lo Lang *being played in the courtyard of the temple. While Lo Lang is popular in the villages of Vietnam, it's less so in the cities. The children say it's because pebbles are easier to find in the countryside.*

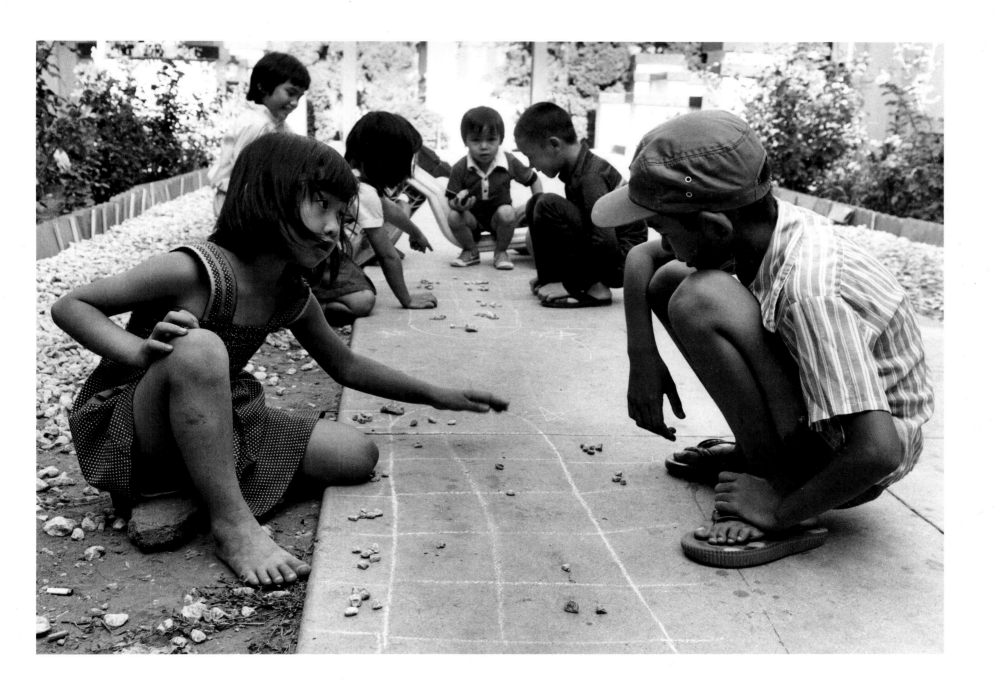

found the Zen master Pai-chang, who was in a direct line from the Sixth Patriarch, Hui-Neng, and was famous for establishing the Zen monastic rule of "no work, no eating." He spent thirty-two years ripening his understanding with Pai-chang, and then returned to the Kien-So temple in northern Vietnam in 820. Among the many illustrious masters of this school, King Ly-Thai-Ton (ruled 1028–54) received the transmission, restored Buddhist shrines throughout the country, and built the famous One Column Pagoda in the old capital of Thang-Long, now Hanoi.

The Zen schools that flourished in Vietnam were central to Vietnamese Buddhism, but they were only half the story. The other half was provided by Pure Land Buddhism.

Pure Land Buddhism is based, as Dr. Thien-An writes, "on recitation of the name of Buddha Amitabha, a form of mantra practice leading to single-hearted concentration through which the other power finds a channel of expression." This "other power" is thought of as the power of the Buddha Amitabha, who once vowed that anyone who recited his name would be reborn in the Pure Land of the Western Paradise, in which it would be easy to attain enlightenment. The recitation of the Buddha's name—*A-Di-Da-Phat* in Vietnamese—is also considered to be the easiest and most direct way to enlightenment in the difficult conditions of the present dark age.

In Japan, the way of Zen is considered the way of self-power, and the way of Amitabha the way of other power, and the two approaches are kept separate and distinct. In Chinese Buddhism, however, Zen and Pure Land teachings were unified. "Pure Land tradition as it developed in China," Dr. Thien-An writes, "evolved from the idea of Pure Land in the West where one seeks entrance by various practices . . . In the process of the Zen–Pure Land Union, the Pure Land came

The courtyard of Chua Viet-Nam—the Vietnamese Buddhist Temple, Los Angeles, headquarters for the Vietnamese Buddhist tradition in the United States.

24

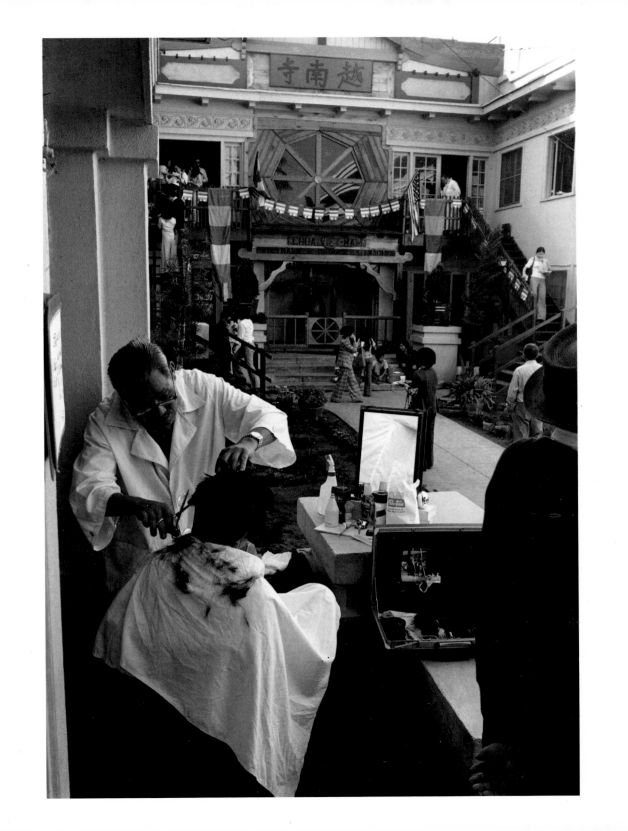

to mean the realm of Pure Mind. Shifting the Pure Land from the beyond to the here-and-now, the beyond within, resulted in recognition of the potentiality of all beings to attain an enlightened state of mind in this very life."

As Thich Nhat Hanh writes in *Vietnam, Lotus in a Sea of Fire*: "The small village pagoda does not have a well-qualified Zen master, since most people, and in particular the villagers, cannot practice Zen as taught in a monastery. This must be performed by qualified monks and possibly by a few educated laymen. For this reason, popular Buddhism in Vietnam is a mixture of some basic Zen elements and many practices of the Pure Land sect. The Vietnamese Zen Masters have thus realized a synthetic doctrine combining Zen and Pure Land practices that suits the masses of the people. Except for the pure Zen monasteries, almost every pagoda in Vietnam practices this combined Zen–Pure Land doctrine."

The union of Zen and Pure Land was the most significant religious development during the Ly dynasty. The succeeding Tranh dynasty, introduced a synthesis that was equally important in shaping Vietnamese Buddhism. This was the unity of Buddhism, Confucianism, and Taoism introduced by the national Zen sect, the Truc-Lam school, which was founded by King Tran-Nhan-Ton (ruled 1225–58).

"By the time of the Tranh dynasty, Vietnamese Buddhism and Vietnamese nationalism were one and the same, not two," writes Dr. Thich Thien-An. "Royal patronage of Buddhism thus included nationalist elements of the popular religious variety, like the cult of national heroes who, by defending their country in times of peril, exemplified to the Vietnamese their own spirit of resistance and represented an embodiment of their national pride. . . . King Tran-Nhan-Ton created an expansive but practical humanism that served both the needs of state and the needs of religion. With the

26

The barber's wife with her youngest daughter and two of her grandchildren in front of their house in Hawthorne, a half hour from the temple.

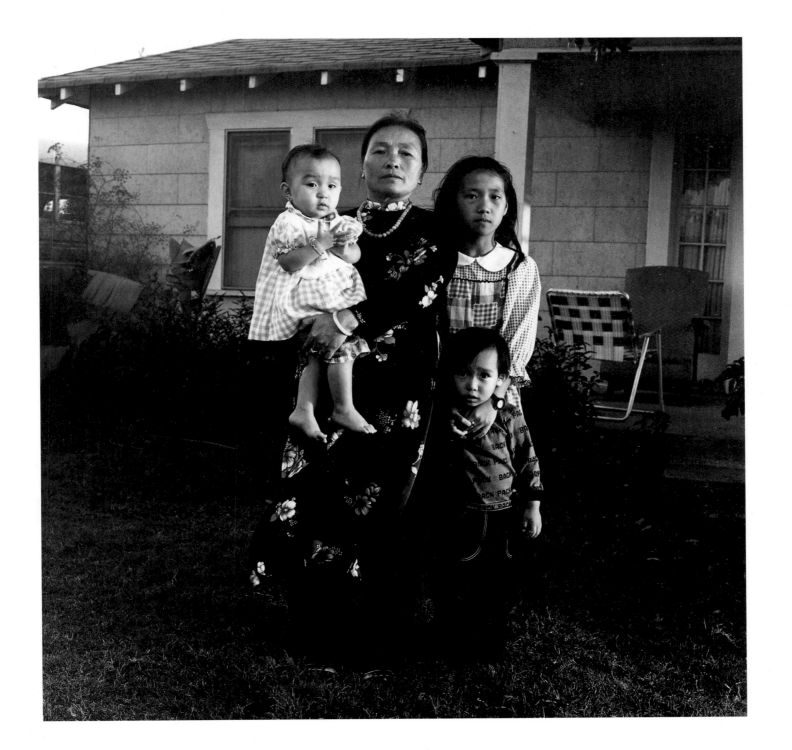

dictum that Buddhism is not to be practiced separately from the world of affairs, he joined the insight of Buddhism with Confucian provisions for human conduct, and demonstrated through his life that the merger of these two religions, so often held to be irreconcilable, could indeed become a living reality in accord with the Tao."

King Tran-Nhan-Ton had been drawn to Buddhism ever since he was a child. "I have always been driven by a passion for spiritual truth," he wrote. "When still very young, I earnestly wished to study Zen Buddhism. I decided to look for a master and to devote my life to religion."

When he was sixteen, his mother died; a few years later, his father, the king, died. "I was extremely unhappy and cried until my eyes were bleeding," he wrote. "From the time I received the throne from him at a young age, I constantly worried and was never at ease. . . . I tried to look for an answer, finally deciding to retire to mountains and forests to study Buddhism. In this way I figured to repay the debt I owed my parents. . . ."

Telling his guards that he wanted to go among the people to know their hardships, he managed to make his way to Phu-Van, the mountain monastery of national master Truc-Lam.

"The master was very glad to see me and calmly acknowledged my presence," wrote the king. "I have lived long in the mountains," the master said, "my bones are hard and my body is thin. I eat vegetables and chestnuts and drink water from the stream. I enjoy this forest scenery; my soul is as light as the floating clouds, and I came here with the wind. Now your Highness has left the throne and come to this humble place; may I ask what your Highness expects to find here?"

"I must rule the country all alone with no one to lean on,"

28

"We have gone through great hardship, but we did not give up hope. Our struggle for survival in a foreign land and our loneliness in this strange country could not deter our faith in the Dharma and in the goodness of human nature."

Thich Man Giac

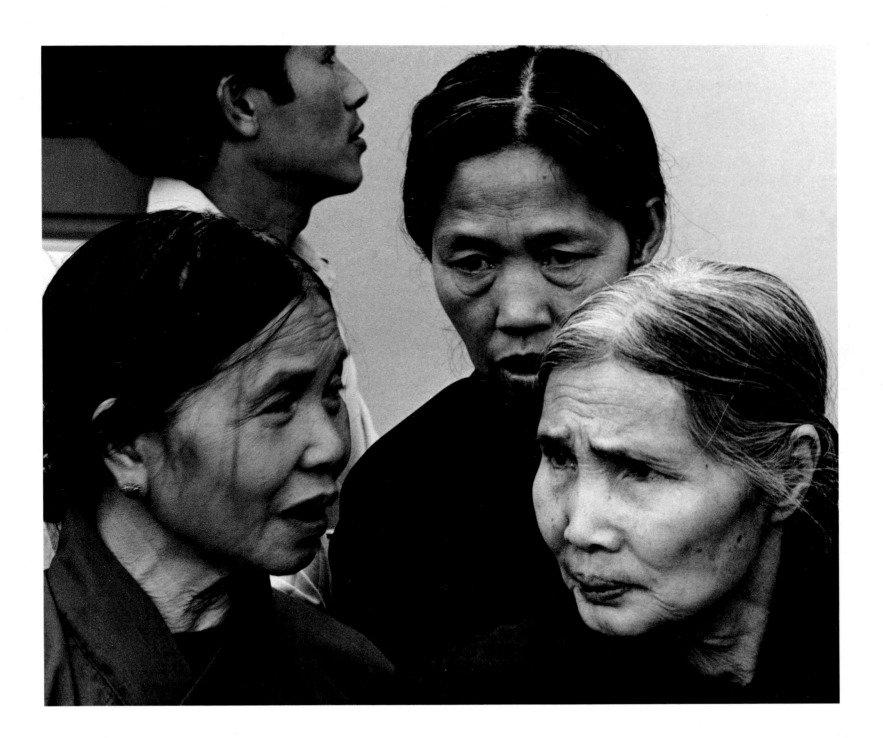

said the king. "I think of my father's life and realize that a king's ambitions sometimes succeed, sometimes fail. I came here to take the Buddhist vow to become a Buddha."

"There is no Buddha in the mountains," the master replied. "Buddha is in the mind's heart. If your mind is calm and understanding, that indeed is Buddha; if you awaken to this mind, you'll become Buddha. You needn't look elsewhere."

Soon after, the king's uncle, who served as prime minister, arrived with a search party and pleaded with the king to return.

The master told him, "A successor to the throne must learn to identify himself with the will of the people and with each beat of their hearts. Now the people want you to return to the palace. How can you refuse? But in spite of your royal position and duties, always continue searching for spiritual truth."

The king reluctantly returned to the throne. "For over ten years, whenever I had any free time from national affairs, I always met with the learned men of the country to study Zen practice and Buddhist teachings," he wrote. "Everyday I read the Diamond Sutra. One day when happening across the sentence, 'Let mind function fixed nowhere,' I put the sutra aside and began to chant the phrase to myself, meditating on its meaning. Suddenly I was enlightened."

King Tran-Nhan-Ton continued to govern and to follow the Buddhist path. "To my way of thinking," he wrote, "Buddhism needs the wisdom of Confucianism in order to function properly within human societies. Is there any reason, then, why I cannot take upon myself both the responsibility of the Confucian sage and the vows of the Buddhist Bodhisattva?"

By the fourteenth century, however, the delicate balance

A memorial service for the 'boat people' who died at sea. Los Angeles Harbor, 1979. "Some of my cousins are still out there," says Mykim. "We suspect the pirates got them."

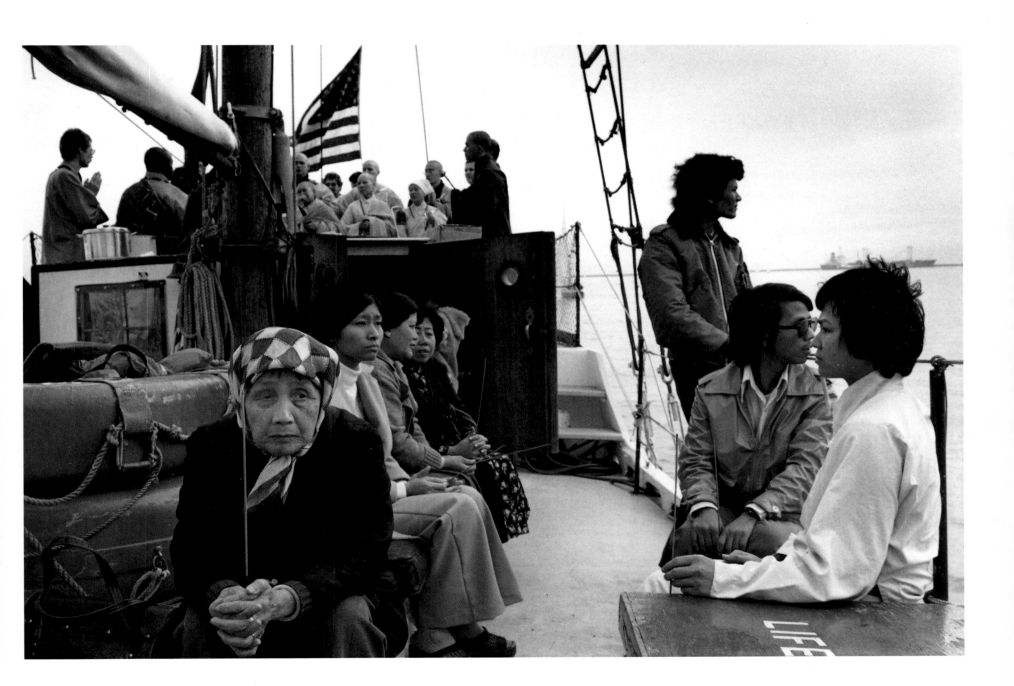

among the three philosophies of Buddhism, Taoism, and Confucianism had become disturbed. Confucianism had gradually come into conflict with Buddhism at the court. King Han-Tran-Hien-Ton instituted an examination for Buddhist monks, and those who failed were forced to return to lay life. When the king attacked Champa, he drafted Buddhist monks into the army—a move many monks resisted by going into seclusion in forest monasteries.

The balance of Vietnamese culture was given a far more serious blow by the arrival of the first European missionaries. In 1627, the French missionary Alexandre de Rhodes reached Vietnam and formulated a system of writing Vietnamese in the Latin alphabet in order to bring French culture and the word of the Christian God to the Vietnamese people.

As usual, European missionary activity and colonialism went hand in hand. In 1861, French forces, charged with protecting French missionary and commercial activities, captured Saigon.

During the nineteenth century, Buddhist monks played an important role in the royalist resistance movement against the French colonialists. An uprising in central Vietnam in 1898, led by a revolutionary monk named Vo Tru, was betrayed at the last minute, and many monks were executed or imprisoned. In the 1920s, the Buddhist revival inspired by the Chinese monk Tsai Hu had a powerful impact in Vietnam, where the drive to modernize Buddhism and make it socially responsible resulted in a proliferation of lay Buddhist study groups and associations.

During the thirties, Vietnamese Buddhists interested in the effect of Buddhism on society began to write about engaged Buddhism, or Nhan Gian Phat Giao, an idea that would play an important part in the Buddhist antiwar struggles of the sixties.

32

Most Vietnamese Buddhists practice in the Mahayana *tradition, which spread from India into China and down into Vietnam. However, about 10 percent of Vietnamese Buddhists practice in the* Theravada *tradition which originally came to Vietnam directly from India with later influences primarily from Cambodia. A Theravada monk gave a group of young Vietnamese boys an opportunity to live as monks for one week. They followed the ancient practice of going out with bowls to gather food from laypeople at their homes and restaurants in the neighborhood. This gave the laypeople a chance to practice* dana, *or giving without expecting anything in return.*

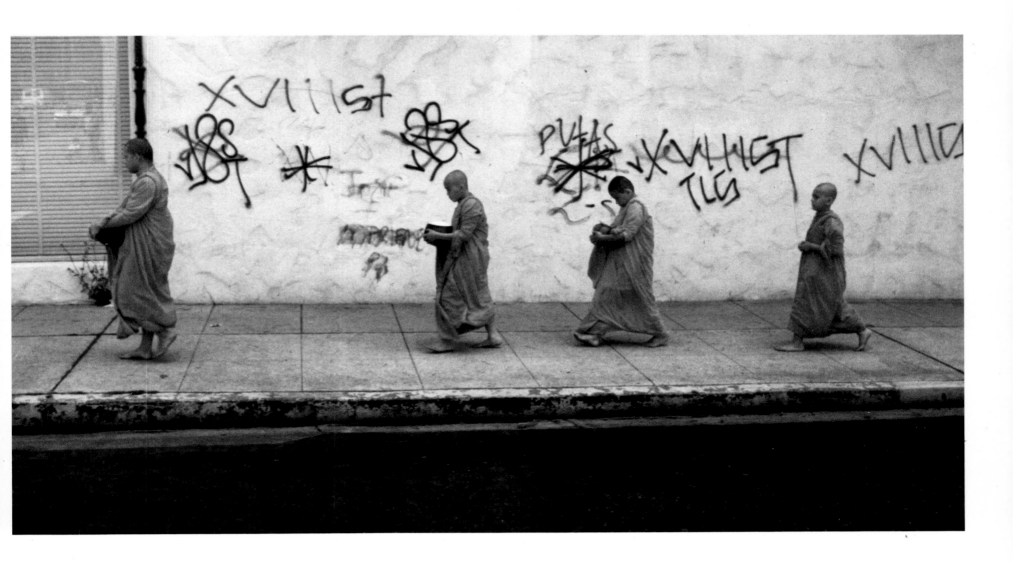

The French had finally been driven from Vietnam after the battle of Dien Bien Phu in 1954. In the partition of the country that followed the Geneva Accords, thousands of Vietnamese Catholics had fled to the South, where President Ngo Dinh Diem had taken over from Bao Dai, the last of the Vietnamese emperors.

Diem's family had been among the first Vietnamese converted to Catholicism in the seventeenth century. He favored the Catholics who had left the North, rewarding them with position, power, and status. His younger brother ruled central Vietnam as his personal domain, while his older brother was the archbishop of Hue.

The Buddhists of Vietnam had grown increasingly frustrated with Diem's favoritism toward the Catholics. They had also found themselves the only voice for the masses of people who were being torn apart by a bloody civil war and called for negotiations and peace in an increasingly polarized situation.

The Buddhists' frustration reached a peak in the central Vietnamese city of Hue on May 8, 1963, as the Buddhists gathered to celebrate the 2,507th year since the Buddha's birth. Just a few weeks before, authorities had allowed blue and white papal flags flown to celebrate the twenty-fifth anniversary of the archbishop's ordination. But now they cited a law, dating back to the French period, that reduced Buddhism to the status of a "private" religion and made it unlawful for Buddhists to meet or gather in any number without permission of the authorities.

The immediate cause of the dispute was that the authorities would not let the Buddhists fly the Buddhist flag. The Buddhist flag had actually been designed in Ceylon (Sri Lanka) in 1880 by an American, Colonel Henry Steel Olcott, a fact that would no doubt have amazed the American mili-

"I realized that it is by watching the Master, his way of living and listening, that you find the things that are useful for your own work. It's not by studying the scriptures hours and hours with explanations of a professor that you find those things."

Thich Nhat Hanh
from The Raft Is Not
the Shore

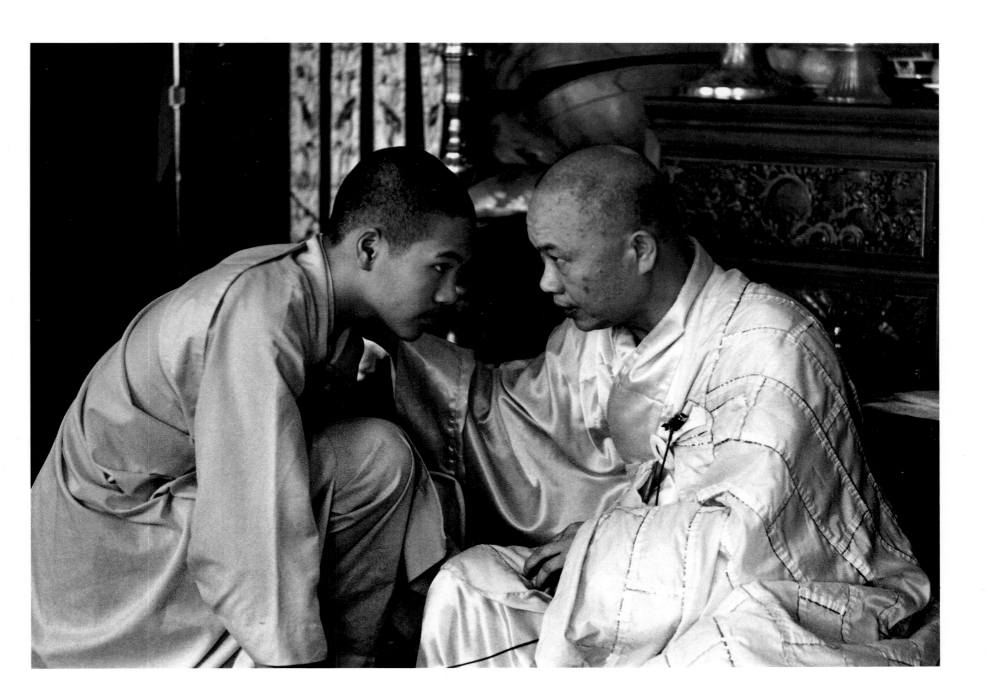

tary men and intelligence gatherers stationed in Vietnam. Olcott had been a founding member of the Theosophical Society, and one of the first American Buddhists. He had been of great help to the Buddhists of Ceylon, who had then been fighting their own battle against Christian favoritism and control.

The flag he designed contained the colors said to have been exhibited by the Buddha's aura during his enlightenment—sapphire blue, golden yellow, crimson, white, and scarlet. In time the flag had come to be accepted by many Asian Buddhists as a symbol of a new Buddhist internationalism, as it was by the Vietnamese Buddhists in Hue on May 8, and as it still is by the Vietnamese Buddhists in Los Angeles and other cities who display it prominently in their temples.

In Hue, on the evening of Buddha's birthday, many people ignored the government's order not to fly the Buddhist flag. Realizing that the situation was getting out of hand, the mayor of Hue allowed the flag to be flown. However, the following evening, when thousands of Buddhists gathered outside the radio station to hear a rebroadcast of the Wesak (Buddha's birthday) celebration, they heard music instead. The station manager claimed that he had canceled the broadcast because a speech by Thich Tri Quang, one of the Buddhist leaders, had not been reviewed by the censor.

While Thich Tri Quang and the mayor of Hue were inside the station discussing the situation, five armored cars arrived at the scene. Orders were given for the crowd to disperse, then shots were fired and grenades thrown. Eight people died in the confusion—seven children and one woman. The Diem government blamed the Communists, but reports by journalists on the scene, as well as by a respected physician who examined the bodies, disproved that claim.

Two days later, on May 10, Buddhist leaders presented the

The Most Venerable Thich Man Giac leading a Buddha's Birthday parade, 1986—the 2530th year since the birth of Sakyamuni Buddha. The temple is in the background.

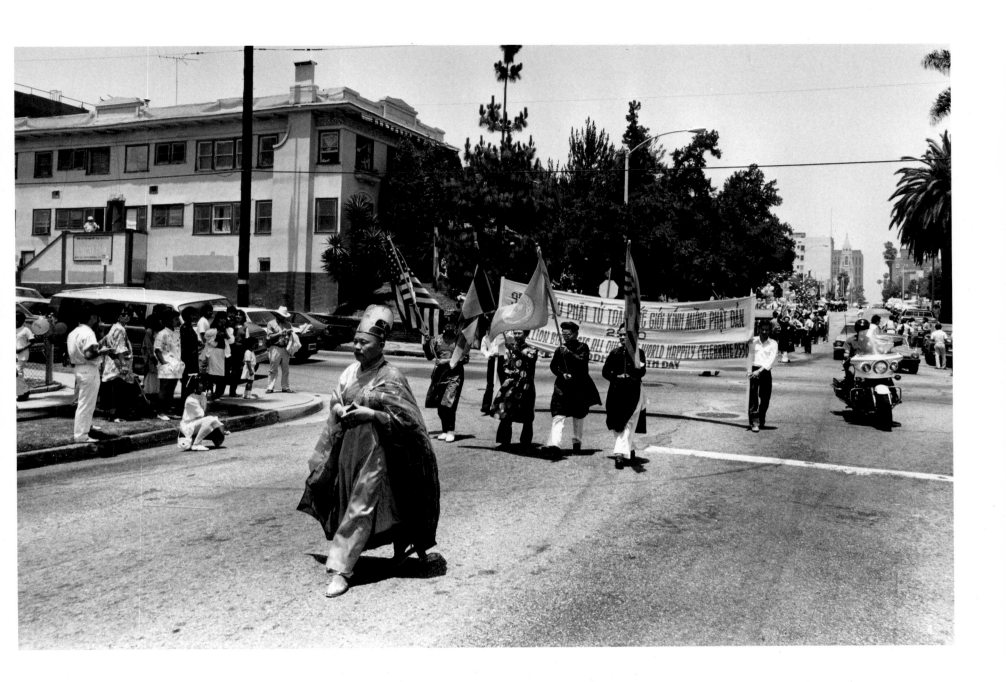

government with five requests: that the government cancel indefinitely the ban on flying the traditional Buddhist flag; that the government grant Buddhism the same rights as Catholicism; that the government stop detaining and terrorizing Buddhists; that the government give Buddhist monks and nuns the right to practice and spread their religion; and that the government pay fair compensations to the victim's families and punish those responsible for their deaths.

A few days later, the Buddhists clarified the nature of their movement. They stated that they were not trying to overthrow the government to form one of their own but merely hoped to change the anti-Buddhist policies of the government; the Buddhist struggle for equality was nonviolent; and the Buddhists did not represent or support the Communists or any other political group.

The Diem government reacted with further repression. Then, on the morning of July 11, as Jerrold Shecter reported in *The New Face of Buddha*:

The orange-robed monks and the grey-robed nuns appeared to be part of a quiet protest as they walked slowly down Phan-Dinh-Phung Street in Saigon on a hot June afternoon. Heading the procession was an automobile filled with monks. At the intersection of Phan-Dinh-Phung and Le-Van-Duyet streets the priests got out of the car and lifted the hood. It appeared that they were having engine trouble. The procession parted around the car as if to move on, but instead the monks and nuns formed a surrounding circle seven and eight deep. Slowly they began to intone the deep, mournful, resonant rhythm of a sutra. The priests in the auto walked to the center of the circle and seventy-three-year-old Thich Quang-Duc sat in the lotus position, a classic Buddhist meditation pose. Nuns began to weep, their sobs breaking the

38

Every Sunday, Long Hoa, the Vietnamese Buddhist Youth Group, gathers inside the temple for a brief chanting ceremony. "We are standing before the Buddha," says Long Hoa member Minh Hien, "seeking the light that he has. We promise to follow his teachings for enlightenment, to be aware of our faults, and to turn our ways to good."

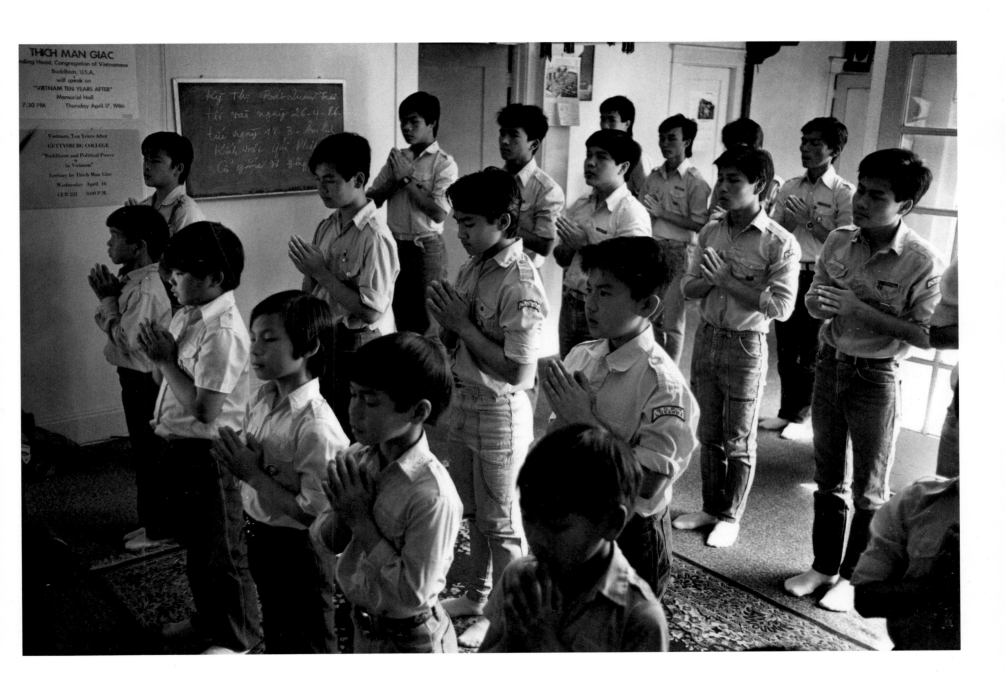

measure of the chant. A monk removed a five-gallon can of gasoline from the car and poured it over Quang-Duc, who sat calmly in silence as the gasoline soaked his robes and wet the asphalt in a small dark pool. Then Thich Quang-Duc, his Buddhist prayer beads in his right hand, opened a box of matches and struck one. Instantly he was engulfed in a whoosh of flame and heavy black smoke that partially obscured him from view. The chanting stopped. The smoke rose and, as the fierce flames brightened, Quang-Duc's face, his shaven skull and his robes grizzled, then blackened. Amidst the devouring flames his body remained fixed in meditation.

Some monks fell to their knees in prayer and began anew the ritual chant of the sutra. . . . Thich Quang-Duc burned for nearly ten minutes before his charred body fell backward, his black flesh and the remains of his robes still smoldering, his serene face fixed in a death mask. Still clutching the prayer beads, his right arm reached to the sky.

The Venerable Thich Quang-Duc, abbot of the Quan-Am temple in Gia Dinh, had left a simple note:

I pray to Buddha to give light to President Ngo Dinh Diem, so that he will accept the five minimum requests of the Vietnamese Buddhists. Before closing my eyes to go to Buddha, I have the honor to present my words to President Diem, asking him to be kind and tolerant towards his people and enforce a policy of religious equality.

The next day, the picture of the monk sitting in flames in the middle of a busy Saigon street appeared on page one of newspapers all over the world. Buddhist organizers had alerted Associated Press correspondent Malcolm Browne; they had also provided reporters with a biography of Thich Quang-Duc, as well as his farewell statement. Americans had

40

"Be awakened, all beings who are sinking in the darkness of ignorance! That is the sacred message of the ringing sent to the ten directions."

Le Hau

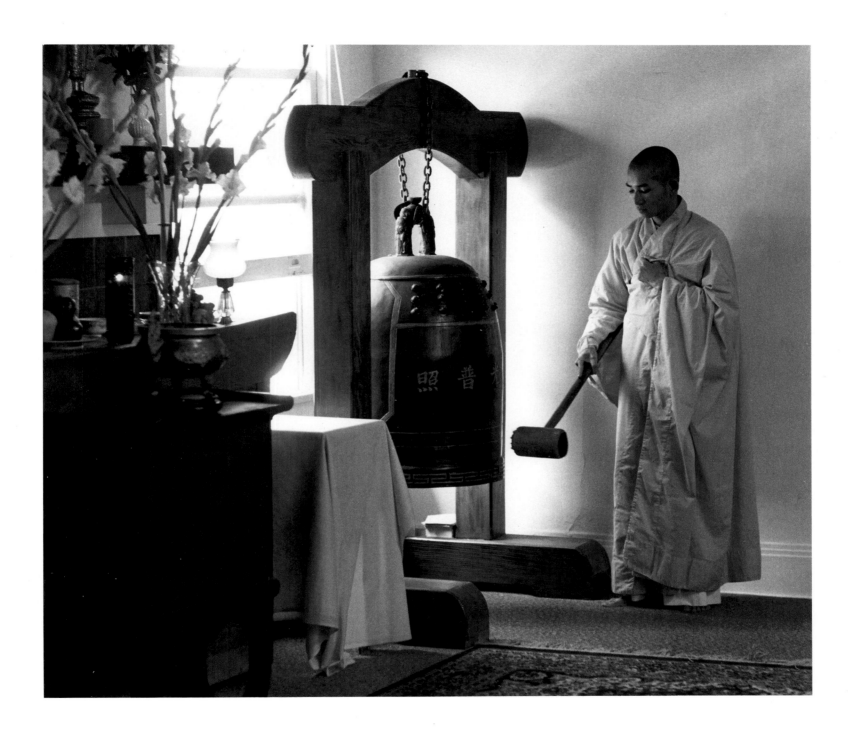

scarcely been aware of Vietnamese Buddhists, but now they had entered their consciousness through the morning newspapers and the evening news in an image that was so shocking and primal that it could not be ignored.

Diem reacted to the crisis with increased repression. He continued to insist that the trouble in Hue had been caused by the Viet Cong. When four more monks burned themselves in August, Madame Nhu—Diem's sister-in-law and a powerful influence in his government—said that more Buddhist suicides would be fine with her. Meanwhile, behind the scenes, the Americans tried to convince Diem to compromise with the Buddhists.

On the night of August 20, Diem's own troops—disguised as regular government soldiers—attacked Saigon's Xa Loi temple with rifles, submachine guns, and tear-gas grenades. They arrested four hundred monks and nuns, including the eighty-year-old Patriarch of the Vietnamese Buddhists. In Hue, monks and nuns in the Dieude temple fought against the attackers for eight hours. Similar attacks occurred throughout the country, and in the end more than one thousand Buddhists—monks and nuns, students, and laypeople—had been arrested.

As Dr. Thich Man Giac wrote, in a paper on Buddhism and politics in Vietnam, "This was the first time in its seventeen-century history that Vietnamese Buddhism suffered such brutal oppression. The entire population was shocked." Young Vietnamese, many of them sons and daughters of government workers and bureaucrats, demonstrated in Saigon. In Washington, Madame Nhu's father, the South Vietnamese ambassador, resigned in protest, and in Saigon, the foreign minister also resigned, shaving his head like a monk.

Thich Thien-An was among the Buddhist leaders and activists rounded up by Diem's men that night. In the summer

42

Each Sunday during the summer three-month retreat known as An-Cu, *the women at the temple prepare a special lunch as a gesture of gratitude to the monks and nuns for carrying on the Buddha's teachings. They are strict vegetarians and before eating, they give thanks to the life taken, even the plant life; to those who grew the food; and to those who bought and prepared it.*

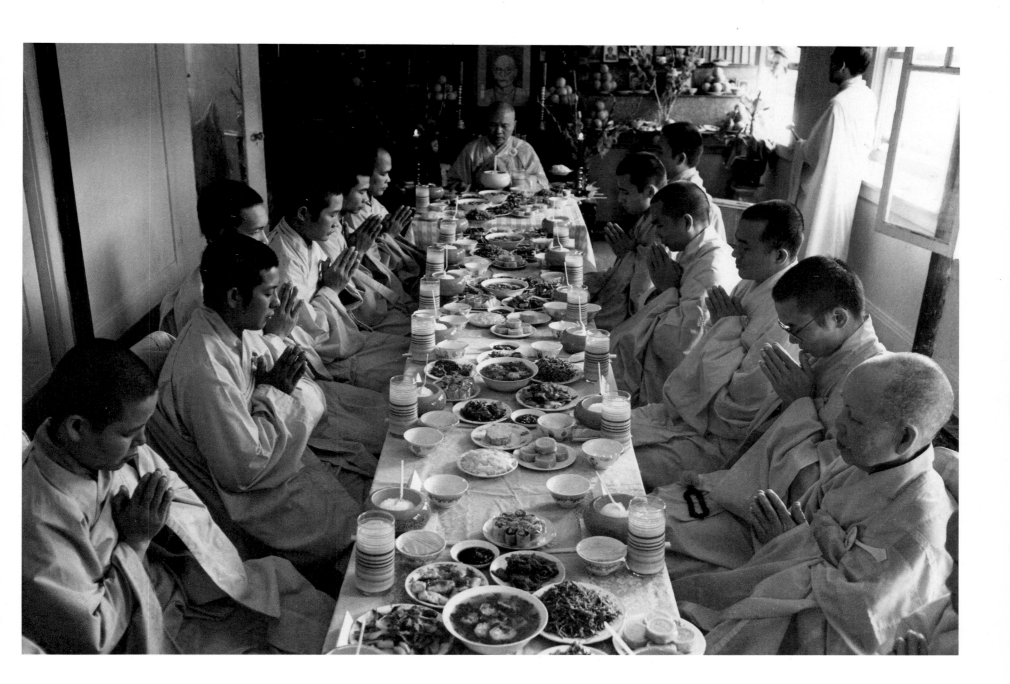

of 1975, I interviewed him in his hotel room in Boulder, Colorado, where he had given a lecture at the newly formed Naropa Institute.

"It seems there is a strong karmic link between America and Vietnam," I said. "How have Vietnamese Buddhists met the political situation?"

"In Buddhism we try not to be too involved in political situations," answered Dr. Thien-An. "However, in Vietnam the majority of the people are Buddhists. So whether we are active or inactive politically, we are still involved in national activity. In 1963, the government arrested many Buddhist professors, monks, and nuns. They arrested me and put me in jail for two months without reason, because I am a Buddhist. So we formed activities against that policy.

"Then another point is this: the American government listened to the propaganda of the Vietnamese government, and they believed that Buddhists are all Communists. But Buddhists can never become Communists. Do you know why? Because Communists are anti-religion. But Buddhists don't like corruption in government either; therefore, they tried to do something to stop that corruption."

My next question was, "Many Americans wonder why Buddhist monks immolated themselves."

"About twenty thousand Buddhist monks, nuns, and professors were in jail," said Dr. Thien-An. "They were arrested by the government and nobody knew. That was an emergency case. I was released from jail by those monks who died, because when they burned themselves, then newspapers, magazines, and television carried the story and also the United Nations sent an investigation delegation to Vietnam, and I was released from jail one night before the delegation arrived. It is like the Christian martyrs. But in Vietnam it is different, because only seven monks dying released and saved al-

44

As the monks and nuns chant at the beginning of lunch during the summer retreat, the laypeople look on and align their prayers with them. They believe that, especially during this time of intense spiritual practice, the chanting of the monks and nuns can help the spirits of their deceased family members by guiding them to the realm known as the Pure Land.

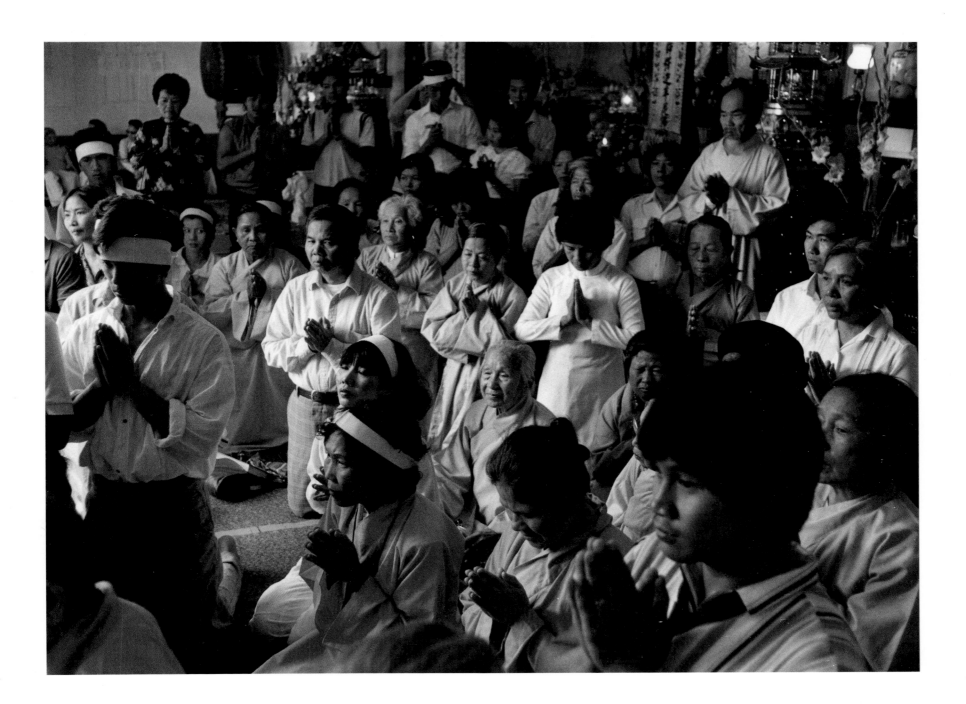

most twenty thousand people from jail. In Vietnam, we consider the first monk to do that a bodhisattva because he died for his religion and to help us. At that time, if no one had done that, then all of us might have died in jail and nobody would have known.

"In Buddhism the first important precept is not killing," he continued. "Not killing oneself and not killing others. But in such an emergency there was no other way to help. They were using their bodies like a lamp for help. And it *was* help. You know, at midnight they moved me from this jail to another, they covered my eyes, and many times I thought, This is my last chance, they are going to kill me. Nobody knew. People here did not know. People in the world did not know. After this kind of dying, people paid attention. We got help from that. That is a bodhisattva. But in regular conditions it should not be done. We don't need that help now. When everybody was in jail, nobody could do anything at all, except some sacrifice like that."

Dr. Thien-An did not mention it at the time, but I later learned that his father, who had become a monk late in life, had been among the first few to make that supreme sacrifice.

Diem was overthrown in a coup in 1963. "Buddhism reached its apex and attracted many intellectuals, students, and youth," according to Thich Nhat Hanh. "However, at this stage Buddhism was not prepared to respond fully to this enthusiastic support. Most of the monks had not been trained to shoulder Buddhism's new mission. They had been trained to recite the sutras, to meditate, and to preach, and now became embarrassed at the role of responsible leadership suddenly thrust upon them."

But if the Buddhists were not able to seize the initiative in the political arena, they did accomplish something very dif-

Walking and chanting Namo-A-Di-Da-Phat—*an expression of reverence to the Buddha of the Pure Land. The phrase* A-Di-Da-Phat *is used instead of hello or goodbye among Vietnamese Buddhists. It means "I respect the Buddha nature in you."*

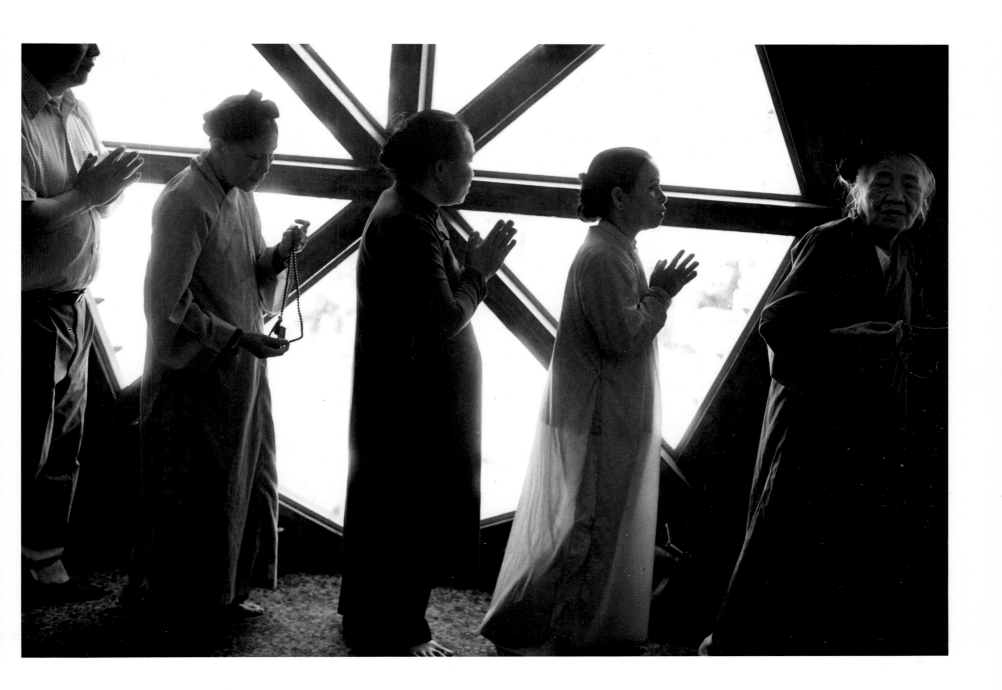

ficult in their own organization. Buddhism had been divided into two great schools—the Theravada and the Mahayana—for more than a thousand years. The Theravada, considered more conservative and orthodox by many scholars, was found in Southeast Asia—Thailand, Burma, Cambodia, Laos, and Sri Lanka; the Mahayana was found in the Northern Buddhist countries of China, Tibet, Japan, and Korea. Vietnam was primarily a Mahayana country, having obtained most of its Buddhism through China, but it also had a small Theravada population.

In 1963, the Vietnamese Buddhists succeeded in forming an organization called the Unified Buddhist Church of Vietnam. The Church united fourteen sects of Mahayana and Theravada Buddhism—something that had never before been accomplished in the history of Buddhism and was a task somewhat akin to uniting the Catholic and Protestant branches of Christianity.

In Saigon, a group of young monks established two publishing houses, Van Hanh and La Boi, as well as a number of Buddhist magazines. The aim of all these projects was to find a way to "actualize" Buddhism, to bring it into practice in modern life. In 1964, Van Hanh University was founded in Saigon. It was modeled on Western universities and began with two faculties, in Buddhist studies and in humanities. Dr. Thien-An became dean of the humanities department. "The education that is needed for the present time," said the rector, Thich Tri Thu, in his inauguration speech, "is one that can wash away, from the innocent minds of the young generation, all the dogmatic knowledge that has been forced upon them with the purpose of turning them into mere tools of various ideologies and parties. Such a system of education will not only liberate us from the prison of dogma, but will also teach us understanding, love, and trust."

48

"Not long ago, I came here one morning to join you in a meditation session. It was still dark when we began. The air was very fresh, the morning very still. We all sat in silence while dawn was still breaking. The sun was coming up on the horizon. Did any of you then realize that we, at that moment, were also having a sun shining forth from within ourselves?"

Thich Man Giac

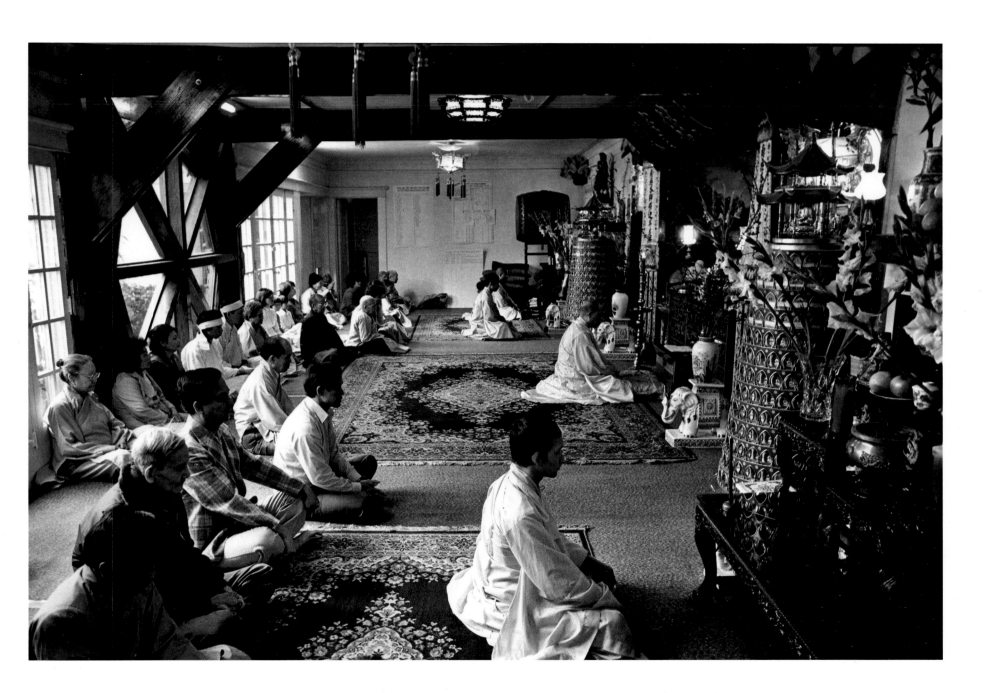

Meanwhile, the generals who had replaced Diem were ousted by General Nguyen Khanh, who was generally pro-Diem. Soon the Buddhists found themselves involved once more in a serious political struggle.

In 1966, the Unified Buddhist Church issued a resolution calling for "free elections and democratic civilian government." The government at first agreed, then stalled for time. Troops from Saigon occupied Danang and Hue, and the country seemed to be on the brink of a civil war within a civil war. As the situation worsened, more Buddhist monks and nuns committed self-immolation. In May 1966, Thanh Quang, a Buddhist nun, burned herself to death. The note she left was addressed to President Lyndon Johnson, asking him not to support the military junta in Saigon. In the following weeks, ten more monks and nuns followed her.

The Saigon government attacked again in Danang and Hue. As a last desperate measure, Buddhists placed their family shrines in the streets to stop the advancing troops. Realizing that the situation was hopeless, Thich Tri Quang told the people to remove their shrines and allow the Saigon troops to enter the city. Then he began a long hunger strike.

As Stanley Karnow wrote in *Vietnam, a History*, "The Buddhist movement never recovered from the defeat." The Buddhists had been unable to find a middle way for a Vietnam torn in half by a war between the Americans and their South Vietnamese counterparts and the Communists. At the same time, Buddhists in Van Hanh University and elsewhere worked to help their country by training and working in war relief, setting up schools and orphanages, and providing a spiritual center.

The war finally ended with the fall of Saigon. In their living rooms, the American people watched this last act on the flickering screen, just as Dr. Thien-An did in his apartment

50

The late Vietnamese Zen Patriarch, Thich Thien-An—founder of the International Buddhist Meditation Center and the Vietnamese Buddhist Temple—leading chants before breakfast during a three-day meditation retreat for his American students: "In accepting this meal, I vow to abstain from all evil, to cultivate all good, and to benefit all sentient beings."

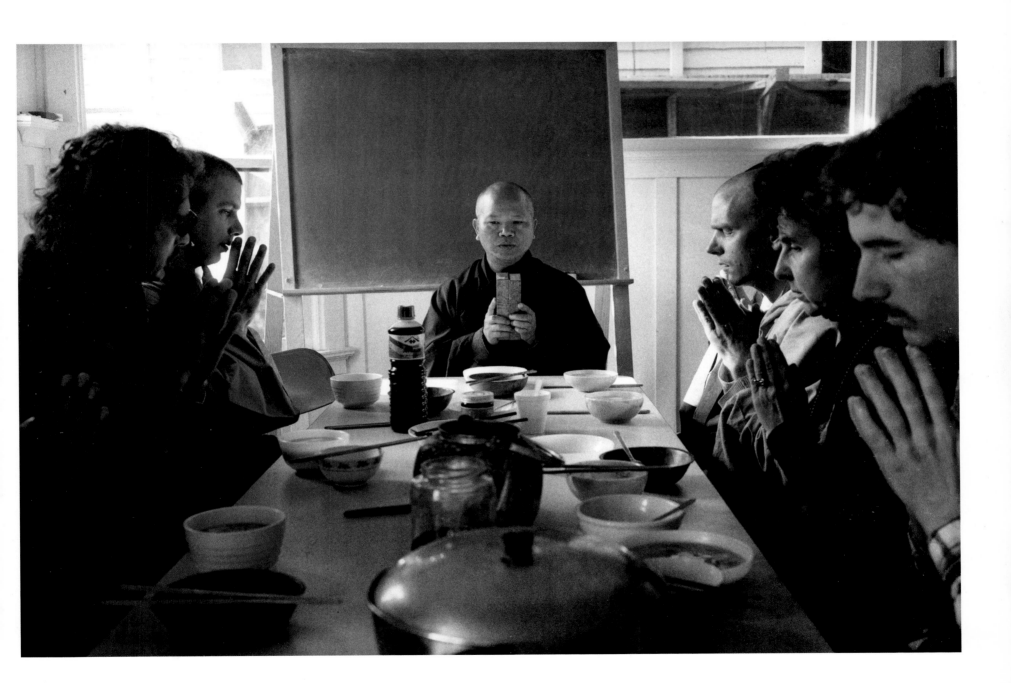

at the International Buddhist Meditation Center in Los Angeles.

In the weeks before the North Vietnamese finally entered Saigon, about fifty thousand Vietnamese and Americans had left the country. On the final day, April 29, 1975, the last-ditch plan for the evacuation of the remaining Americans and the Vietnamese who had worked for and with them went into action. It took eighteen hours for seventy marine helicopters to carry one thousand Americans and almost six thousand Vietnamese to safety. While the North Vietnamese shelled the airport, Ambassador Graham Martin, the American flag tucked under his arm, left on a helicopter from the embassy roof.

The Vietnamese who had managed to get out during those days of panic and chaos tended to be well connected to the departing Americans—politicians, military men, technicians, bureaucrats, professionals, and their families. They formed the vanguard of the Vietnamese emigration to America, though at the time nobody knew how many would follow them, and at what cost.

There was hope at first among some Vietnamese that the departure of the Americans and the forcible reunification of the country would at last result in a new era of peace after hundreds of years of fighting (or thousands, if you counted the on-and-off battles with the Chinese). There was hope that the Vietnamese, left at last to their own destiny, could set about the business of rebuilding their war-ravaged country.

It turned out, however, that many Vietnamese, even those who had fought alongside the Viet Cong in the South, had much to fear. As the hard-liners and ideologues from the North consolidated their control of the South, many Vietnamese were taken away to "reeducation" camps from which

52

"In Zen, we calm and quiet the mind to discover our true self, our inner self. Not only to make the wind stop in order to have a quiet lake, but after the lake is quiet, we can see the bottom of the lake. Then the sun and the moon can have a clear reflection."

Thich Thien-An

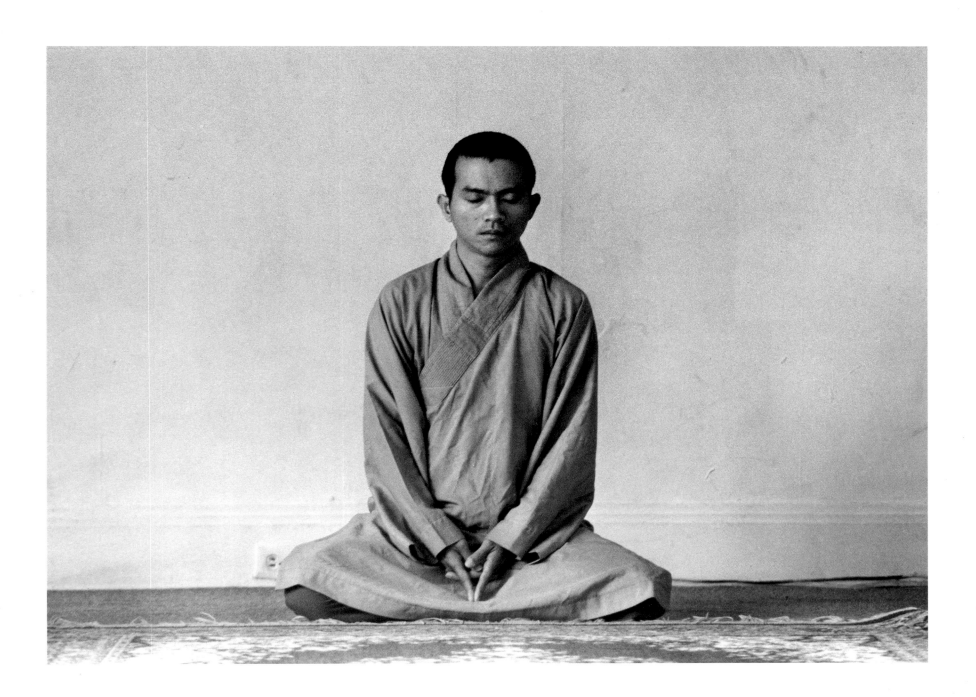

many have never returned. Peasants, used to tilling their land for thousands of years, resisted the collectivization called for by a five-year plan, and suffered for it.

James Forest wrote in a pamphlet on the Unified Buddhist Church published by the International Fellowship of Reconciliation:

Tragically little social justice was forthcoming. Though the UBC had been responsible for a mass movement of opposition to the Saigon regimes and American intervention, reports quickly began reaching the UBC headquarters in the An Quang Pagoda of brutal treatment of Buddhist workers and clergy: orphanages confiscated, social service centers closed, pagodas seized or destroyed, religious statues smashed, the same Buddhist flag that Diem had attempted to ban once again prohibited.

The Most Venerable Thich Man Giac, who served as the UBC's commissioner general, has described the situation succinctly: "Buddhism was a marked object of oppression and discrimination during the French domination and during the Diem and Thieu regimes. The fate of Buddhism is no different under Communist rule. The only difference is that now other religions—including Catholicism—also have to share this misfortune."

The most dramatic opposition to the anti-Buddhist policies of the new regime occurred at midnight on November 2, 1975, when twelve monks and nuns of the Duoc Su Zen monastery in the village of Tan Binh immolated themselves.

The monks and nuns of the monastery had been forbidden by local authorities to hold a commemorative service for two nuns who had immolated themselves for peace in 1972 and 1975. The local authorities had also prohibited the abbot of the monastery, the Venerable Thich Hue Hien, from display-

During twenty-four hour retreats, the laypeople practice Niem Phat *or recitation of the Buddha's name; chant* sutras—*the teachings of Sakyamuni Buddha; and chant* mantras *which, according to the monks, need not be understood. "When I chant the mantra, I feel peaceful," says Thich Tanh Thien.*
Nam-mo a di da ba da, da tha da da da,
Da dia da tha.
A di ri do ba ty,
A di ri da tat dam ba ty,
A di ri da ti ca lan de,
A di ri da ti ca lan da,
Da di ni da da na,
Chi da ca le ta ba ha.

54

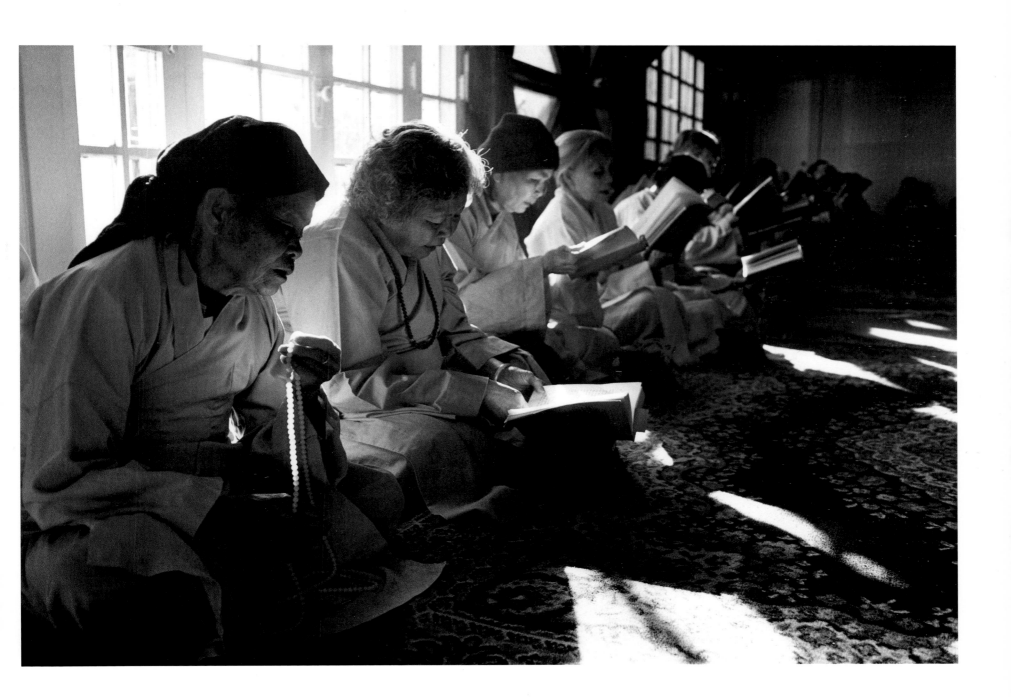

ing the traditional Buddhist flag. Monks and nuns were also forbidden to go into retreat and observe silence. The abbot was required to expound "the glorious, historical, and great victory of the Revolution among the monks and nuns of the monastery." Finally, the monastery was forbidden to accept new members.

The monks and nuns had left a letter communicating their prayers for the preservation of the Buddhist teachings, as well as an "appeal to the Revolutionary Government . . . to respect the right to freedom of worship of all religions."

The government reacted by confiscating the bodies and arresting anyone who came to the pagoda. Unlike the immolation of Thich Quang-Duc in Saigon, which had been broadcast all over the world, no one outside Vietnam knew of the desperate measures taken by twelve Buddhist monks and nuns in this village temple. It was not until months later that smuggled copies of their letters reached Paris, where they were released to the press by the Vietnamese Buddhist Peace Delegation.

On January 22, 1977, nearly three hundred delegates of the United Buddhist Church managed to make their way to a meeting at An Quang Pagoda in Ho Chi Minh City (formerly Saigon) despite the fact that the government had ruled that only the Liaision Committee of Patriotic Buddhists was legal. The Buddhists at the An Quang meeting pooled their information and learned that the anti-Buddhist activities of the new government were not, as many had hoped, the result of zealous local revolutionary committees but part of a nationwide pattern. "We cannot reproach the authorities for not being fair during the very first months of rule," said the leaders of the Church. "But now, twenty-two months later, we wish the government to hurry, to have a fair policy toward Buddhists."

56

An eldest son pours a cup of tea as a symbolic offering to the spirit of his father who died in Vietnam. At the same time, the monks chant to guide his father's spirit to the Pure Land. White gowns are worn during these services.

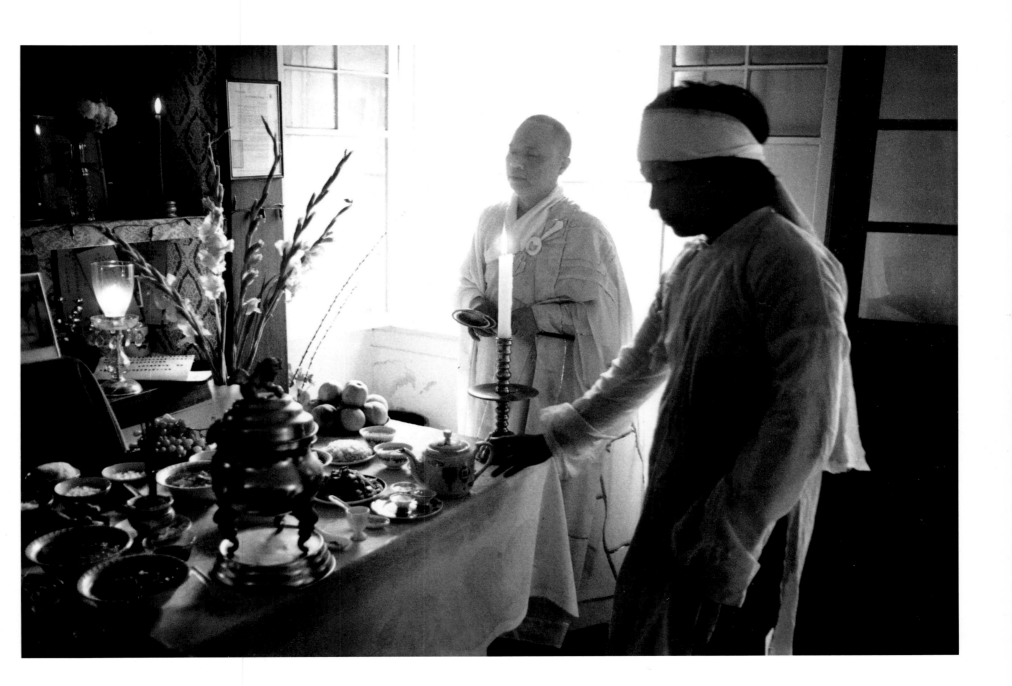

The government of the Socialist Republic of Vietnam reacted with repression—just as the governments of Diem and Thieu had. On April 7, 1977, they arrested six leading monks at An Quang Pagoda. These included Thich Quang Do, general secretary of the Central Executive Council, who had been tortured under Diem; Thich Huyen Quang, executive vice-president of the Council, who had also been a prisoner under Diem; and members of the Committee of Clergy Self-Support.

The Church reacted with "An Appeal for the Protection of Human Rights." The text, as well as other material on the suppression of Buddhism in Vietnam, was entrusted to Thich Man Giac. He slipped out of Vietnam at night on a small fishing boat, as so many other refugees were now doing. He survived the sea voyage and carried his documents to Paris, where they were delivered to the Vietnamese Buddhist Peace Delegation.

In 1978, the Vietnamese Army invaded Cambodia, which had been suffering under the ruthless Pol Pot regime, and there were border skirmishes between China and Vietnam. The sizable ethnic-Chinese minority in Vietnam came under increasing repression, and a new wave of people left the country, buying exit visas with gold. They were soon joined by thousands of Vietnamese boat people, who fled the country in crowded fishing boats and junks. Many drowned at sea. Many others became victims of Thai pirates who raped and pillaged and murdered their helpless quarry. The ones who did make it languished in refugee camps in Thailand or Hong Kong.

The Vietnam War was over, but the suffering of the Vietnamese people was not.

"To be allowed out, you had to pay three ounces of gold for each person," said one of the boat people. "We sold every-

Families come to the temple every Sunday during a forty-nine day period after a loved one has died. It is believed that after this amount of time, the spirit is reborn.

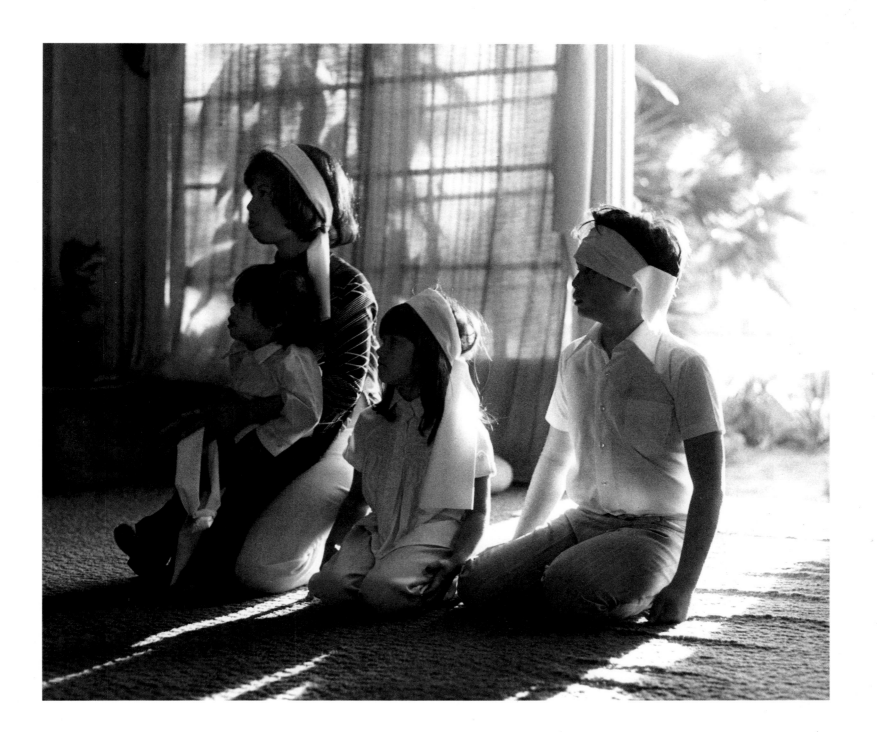

thing and borrowed from everyone we could to get enough. It was a fifty-foot boat, not built very solidly. There was only room for two hundred people, but at the last minute they put forty more people on board. Not to speak of lying down to sleep, there wasn't even room to sit down.

"It took us nine days to reach Malaysia. For the last seven days, there was no more water to drink. The Buddha's light was protecting us, for if there had been a storm or if it had taken much longer to get to Malaysia, we would not have survived."

The plight of the boat people captured the imagination of many in the West, but the Vietnamese refugees in the United States were especially concerned. Some had made their own escape and were all too aware of the dangers and hardships. Others had friends and relatives who were trying to leave, though they could not know if they would succeed.

The morning of Saturday, January 13, 1979, was cool and clear—a perfect Southern California day—as Dr. Thien-An and a group of monks wearing saffron robes and with their heads freshly shaved boarded *Le Braconnier*, a sixty-five-foot motorized sailboat, along with American and Vietnamese laypeople, and sailed out of San Pedro.

Dr. Thien-An and his party sailed through the weekend crowd of small pleasure craft and fishing boats into the open sea. Looking toward the horizon, they reflected on the boundlessness of the sea and on the vulnerability of those who had set forth from Vietnam. Many of the Vietnamese on board had taken a similar voyage themselves, and they knew how helpless they were to help their relatives and friends who might be on that sea.

This did not mean that nothing could be done: Buddhist ceremonies reach out to all realms. The boat people themselves sought safe passage by chanting Namo-Quan-The-Am-

60

A family returns to the temple for a service when one hundred days have passed following the death of a family member. They come back for these services once a year thereafter.

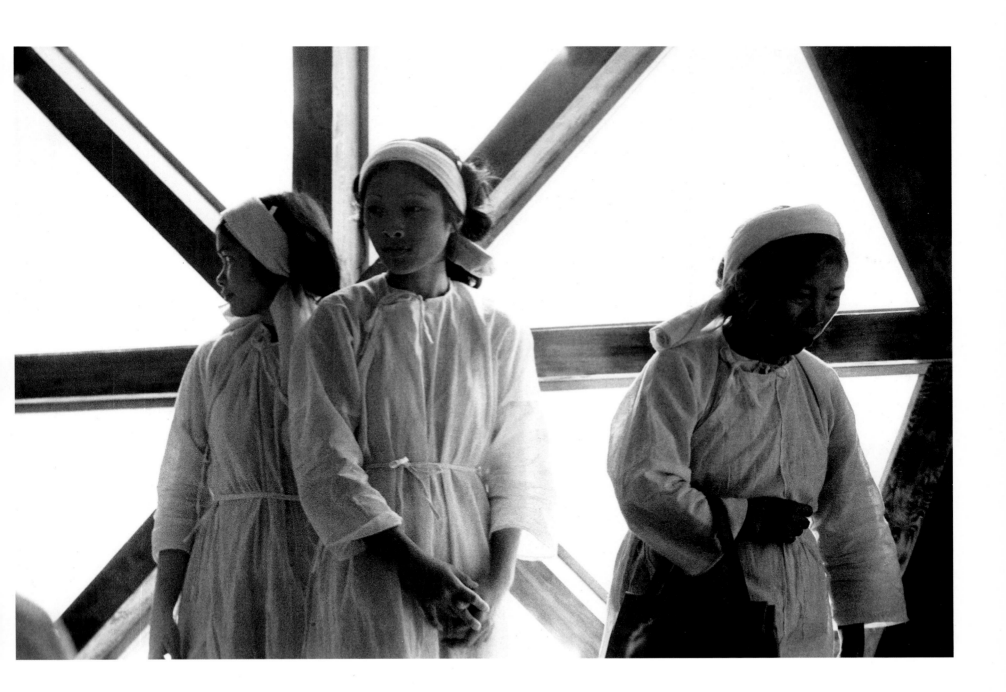

Bo-Tat ("Hail, Quan-Am Bodhisattva"), their hands clasped in prayer as they sailed, visualizing the figure of Quan-Am Bodhisattva standing on the sea, watching over them with great compassion.

The Vietnamese believe that the spirits of the dead wander in the ocean until they are reborn. To help assuage their suffering, the people on the boat off Los Angeles burned incense, chanted, and threw offerings of food and paper money into the water.

"The significance of conducting the ceremony out at sea was felt by all of those participating," remembers an American Buddhist monk, Thich An-Tu. "There was a sense of oneness with the dispossessed who had lost sight of land and were at the mercy of the boundless ocean."

When Dr. Thien-An and the others returned to the dock, they carried a bucket of seawater. They took the bucket to the temple, where further chants, prayers, and offerings were performed over the miniature ocean that stood for the vast expanse of sea. In Buddhism, the part often stands for the whole.

The Most Venerable Dr. Thich Man Giac reached the United States in 1978. Like his friend and colleague Dr. Thich Thien-An, Dr. Man Giac was a meditation master in the Lam-Te lineage and a scholar. He had earned a Ph.D. in Oriental philosophy from Tokyo University, where he had studied with the celebrated Japanese philosopher Hajime Nakamura.

Dr. Man Giac had taught at Van Hanh University and Saigon University, and his visit to institutions of higher education in the United States in 1968 had been sponsored by the State Department. He was also a celebrated poet in his own country.

This young woman's boyfriend was a pilot in the South Vietnamese air force and was shot down during the war. She wailed in sorrow during a memorial service that took place not long after the refugees first arrived in the United States.

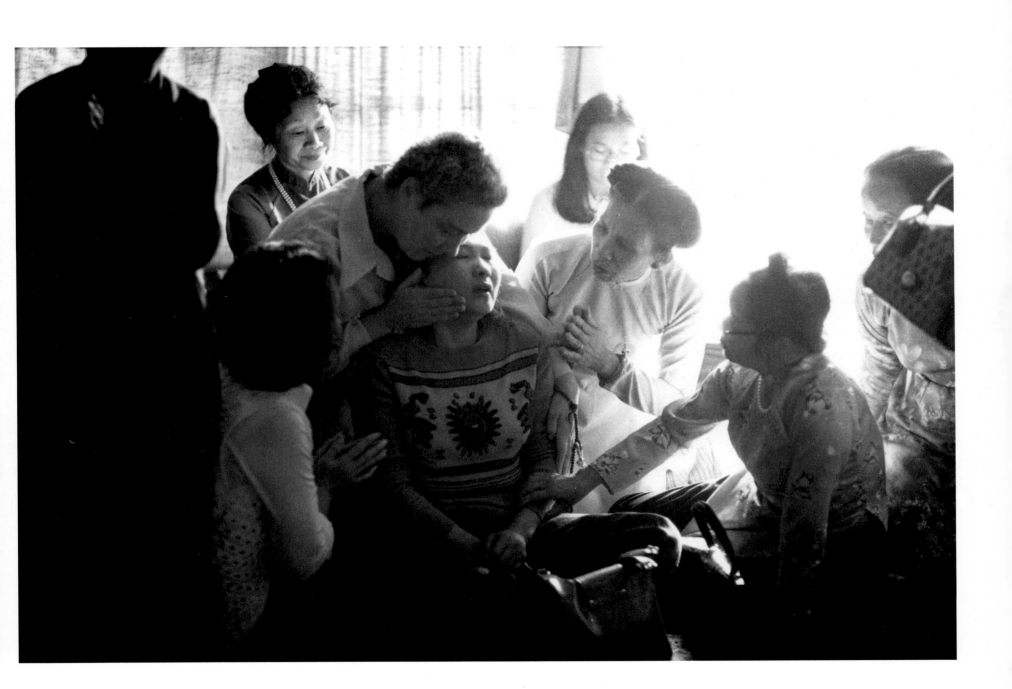

In Los Angeles, he was reunited with Dr. Thien-An, one of the founders of Van Hanh University, which had now been closed by the Communists. At first, Dr. Man Giac ministered mainly to the needs of the Vietnamese Buddhists, while Dr. Thien-An continued to work with both Vietnamese and Westerners. Together, they established the Vietnamese Buddhist Congregation in the United States.

"Teaching Buddhism in the United States for twelve years has shown me that if we want to establish a strong and growing Buddhist tradition there, we must base our growth on the principles of Mahayana Buddhism, which allows for change whenever it is necessary to meet the needs of a new land," Dr. Thien-An told a meeting in Taiwan. "I think we need to have the Buddhist training done in an American Buddhist university in the language which suits the Western culture"—which, of course, was the role he saw played by the University of Oriental Studies he had founded.

"When Buddhism becomes a strong organization and a main spiritual power in a strong country like the United States," he said, "then it will not only grow there but in other countries as well. Until now, Buddhism has spread from East to West. With this new growth, it would be possible to bring Buddhism from the West back to the East again. At that time, the Asian countries that are blindly living a nonhumanitarian existence will open their eyes and be happy to receive Eastern wisdom again."

In the fall of 1980, it was discovered that Dr. Thien-An had developed a brain tumor. During surgery, it was found to have metastasized from cancer of the liver. Dr. Thien-An went back to work. On the evening of November 21, he called Sister Karuna to his house, saying, "It is urgent." He had been vomiting blood. He insisted on putting on clean robes, but his fresh robes were soon covered with blood. Sis-

Do Khanh escaped Vietnam by boat and spent thirteen months in a refugee camp in Malaysia. He had just arrived in Los Angeles and was staying at the temple until he got settled. "Right now, I worry about my mother and my brother. They are in Indonesia in a refugee camp."

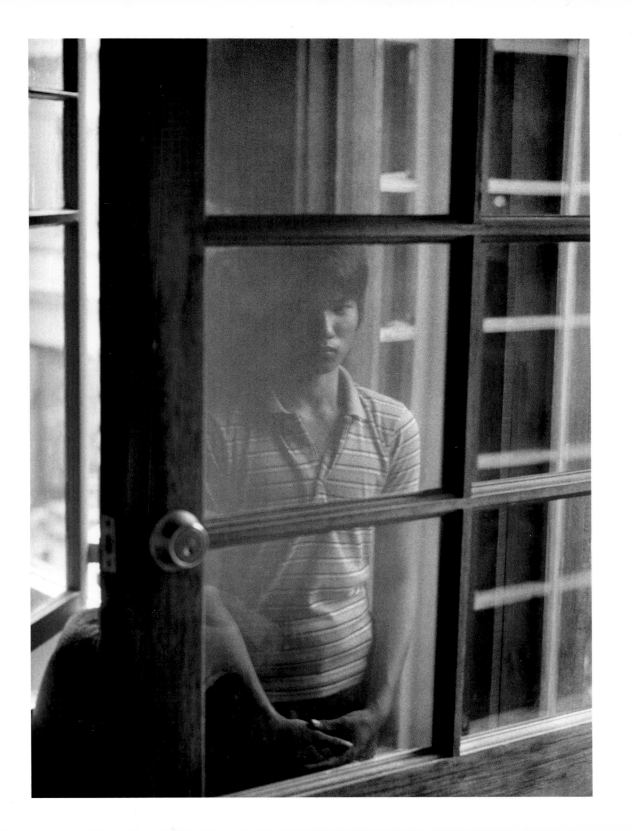

ter Karuna speeded with him through the streets of Los Angeles. "It's O.K.," he told her, his hand on her arm. "Slow down. Don't go so fast." He died on the morning of November 23.

The motorcade to the cemetery contained five hundred cars. Sister Karuna, who had been Dr. Thien-An's disciple for twelve years, became the abbess of the International Buddhist Meditation Center. The Most Venerable Dr. Thich Man Giac took Dr. Thien-An's place as supreme abbot of the Vietnamese Buddhist Churches in America.

Four years later, Thich Man Giac addressed the World Fellowship of Buddhists in Colombo, Sri Lanka, in his office as supreme abbot and as "the second Vietnamese-American Buddhist patriarch." Thich Man Giac quoted some lines from the Vietnamese Zen Master Van Hanh:

Everything is blossoming when spring comes
And all is fading away when fall returns.
Do not be afraid of the various vicissitudes of life
Which are like a dew-drop on the leaf of grass.

"Not to be afraid of anything is the greatest message of Vietnamese Buddhism which we have inherited for more than two millennia of the historical struggles of the Vietnamese people," he said, "and now we are trying to bring this spiritual message to the United States as the core and gist of the Buddha's Teaching for the American people and the West.

"The Vietnamese Buddhists are going through one of their greatest tragedies. They are being persecuted cruelly and relentlessly by the Vietnamese Communists, but we never forget that we are never afraid of anything. Everything is coming and going away, but the Buddha-Dharma prevails."

66

A vegetarian lunch is served to everyone after the ceremony on Sundays. The contribution that the women make—bringing food, cooking, and cleaning up after meals—helps create for everyone who comes to the temple a sense of being part of a family.

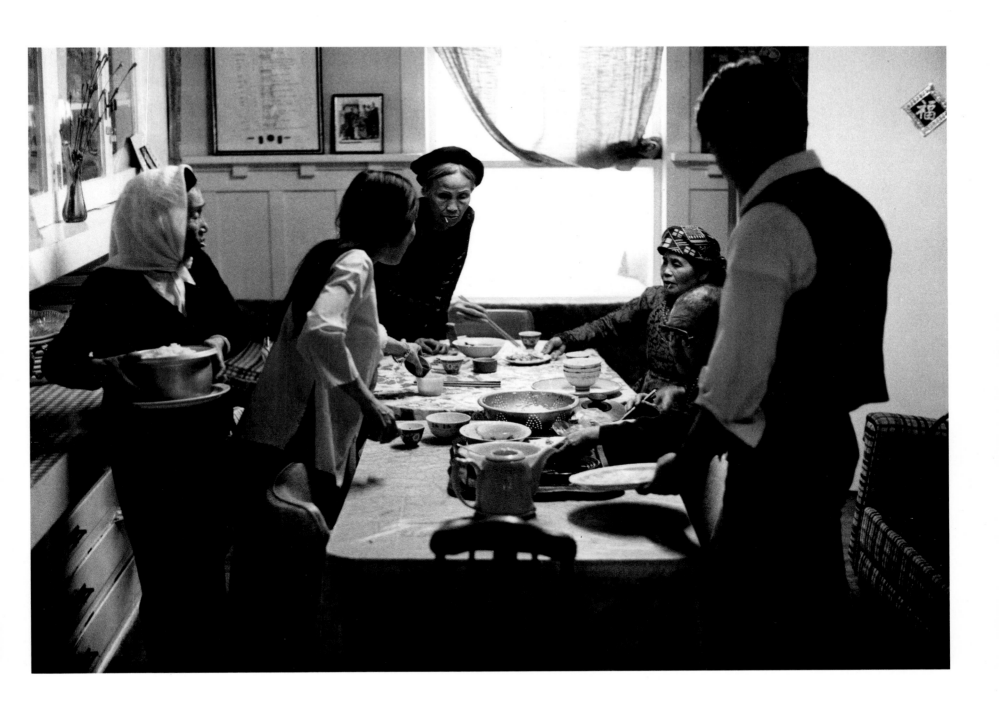

It's a Sunday in Los Angeles at the Vietnamese Buddhist Temple. In Vietnam, the big temple bell would already have rung, as loud and as often as a rooster's crow at five in the morning, but here in America, in deference to the neighbors, it will not ring until the sun has already long risen.

Chua Viet-Nam, the Vietnamese Buddhist Temple in Los Angeles, serves as a center and as an anchor for the Vietnamese Buddhist refugee community and their children, many of whom now speak English more naturally than Vietnamese. But the temple is also home for a group of about twenty monks—sometimes fewer, sometimes more—many of whom have lived in temples since they were seven years old. Others became monks more recently, and a few have become monks since arriving in America. There are also nuns who take part in the services of the temple but live in their own A-Di-Da temple, about half a block away.

The monks rise at five in the morning to begin their day with meditation. Often it is Zen (Thien) meditation in the classical sense, using koans handed down from the Chinese patriarchs of the Lin-Chi school, or the "silent" meditation of the Soto school.

On Sundays, they might help with preparations for the day, or, if there is enough time, they might do something monks in Vietnam would never have thought of doing— open a textbook on electrical engineering or on computer programming and data entry.

In Vietnam, as in most traditional Buddhist countries, monks and nuns were supported by laypeople. But now, everything has changed. The energies of the new refugees are of necessity taken up with the problems of getting a foothold in a new country and culture. "Life here is like a machine,"

"There are two ways to wash the dishes. The first is to wash the dishes in order to have clean dishes and the second is to wash the dishes in order to wash the dishes. If while washing the dishes, we think only of the cup of tea that awaits us, thus hurrying to get the dishes out of the way as if they were a nuisance, then we are not washing the dishes to wash the dishes. What's more, we are not alive during the time we are washing the dishes. In fact we are completely incapable of realizing the miracle of life while standing at the sink. If we can't wash the dishes, chances are we won't be able to drink our tea either. While drinking the cup of tea, we will only be thinking of other things, barely aware of the cup in our hands. Thus we are sucked away into the future—incapable of actually living one minute of life."

*Thich Nhat Hanh
from* The Miracle of Mindfulness!

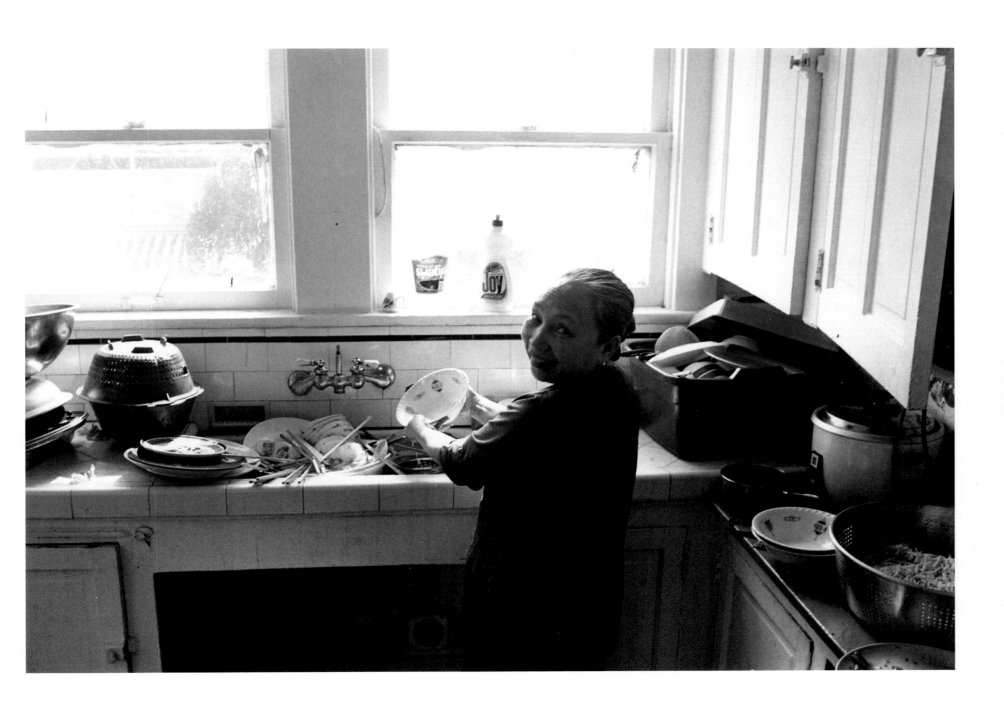

one of the monks observes. "People have to work very hard to buy a house, to have a car, to educate their children. Life was slower, and there was more time in Vietnam."

So some of the monks work outside, partly not to be a burden on the community and partly to insure that they will be able to continue their vocation no matter what happens. This is not without precedent in Buddhism. The first Buddhist monks, the disciples of Sakyamuni Buddha in India, lived completely on alms. But in China, Japan, Korea, and Vietnam, Zen monks farmed and foraged to support themselves. What will happen in America is an open question. If the monks spend too much time working at secular jobs, they worry that the laypeople will not respect them and that they will not have time for their religious duties.

Many of the monks at the temple left Vietnam secretly by boat. Some spent time in large, primitive and brutal "reeducation" camps in the jungle. Since the communist victory, many Vietnamese Buddhist leaders, including the supreme patriarch of the Vietnamese Buddhist tradition, have died in prison.

Thich Vien Ly, who left Vietnam in 1982 by boat, tells a typical story.

"They said I was a CIA agent, and that Buddhism is very dangerous," he says. "The first four months, I stayed in a cell with a pail to use as a toilet. Once a day, a small bowl of rice and water would be passed through the door. Every day, I would be taken into an office and be interrogated. I had to sit on a stool, and if they didn't like my answer they would kick and slap me. One time, I was kicked over and I fell back and went unconscious for perhaps five minutes. The first two weeks I was kept in leg irons. I could not stand up. . . .

"They told me if I take off my robe and stop being a

70

The game Co Tuong, *being played in a monk's room, originated in China and is similar to chess, but, instead of looking like knights, pawns, and so on, the pieces are described by Chinese words carved into them.*

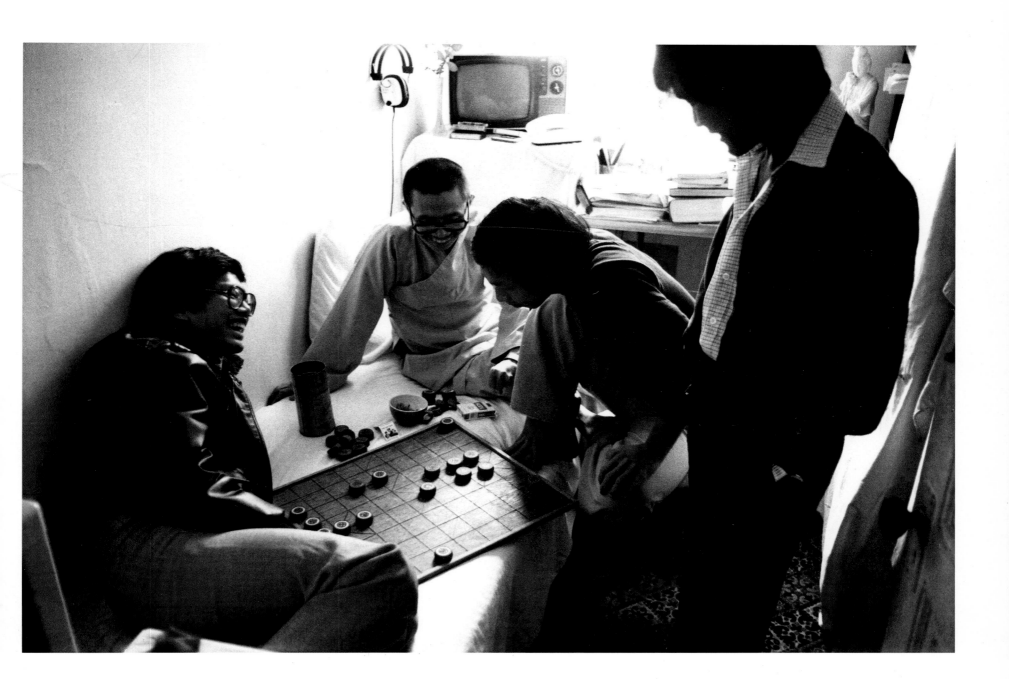

monk, they would let me free. I told them I became a monk when I was seven years old, and I told them I study and understand Buddha's teaching. I want to help people become kind people, to become good people, to make a peaceful world. I love peace. I hate war. I told them, If you think I am a dangerous criminal, you can hold me until I am not dangerous. I cannot throw away my Way."

Vien Ly was arrested and escaped three times before he finally made his way to the United States. "The most important thing we can do is to help people to become Buddha," he says, "to deliver them from suffering. When the monks come to America, we don't want a car, we don't want beautiful clothes, or a big house, or comfort, but what do we want? We want to have the freedom for religion, speech, to go anywhere, all the freedoms. We want to be able to give a sermon to anybody."

Though most of the monks at Chua Viet-Nam became monks in Vietnam, a few discovered Buddhism after arriving in the United States. Thich Tanh Thien, for instance, served as a mechanic in Vietnam, repairing C119 cargo planes. He was working at the airport during the fall of Saigon when he saw a 130 cargo plane taking off, with crowds of people running behind it. "I wasn't sure where the plane would go," he says, "but I followed the people. Rockets were exploding in the airport. I could see that they wouldn't let people go outside the gates and they wouldn't let people go inside. While the plane was moving, I ran after it and jumped into the back." He eventually arrived at Camp Pendleton, and soon he got a job working on an assembly line making water pumps and studied English at night school in Santa Ana. He happened to visit Chua Viet-Nam for the first time the day it opened.

"I think that I was very lucky," he says. "I became a monk

A pigeon flew down to the hands of the young monk, Chinon, who had taken care of the bird when it was injured. Buddhists traditionally describe enlightenment as being like a bird's flight that is only possible when one wing is compassion and the other is wisdom.

72

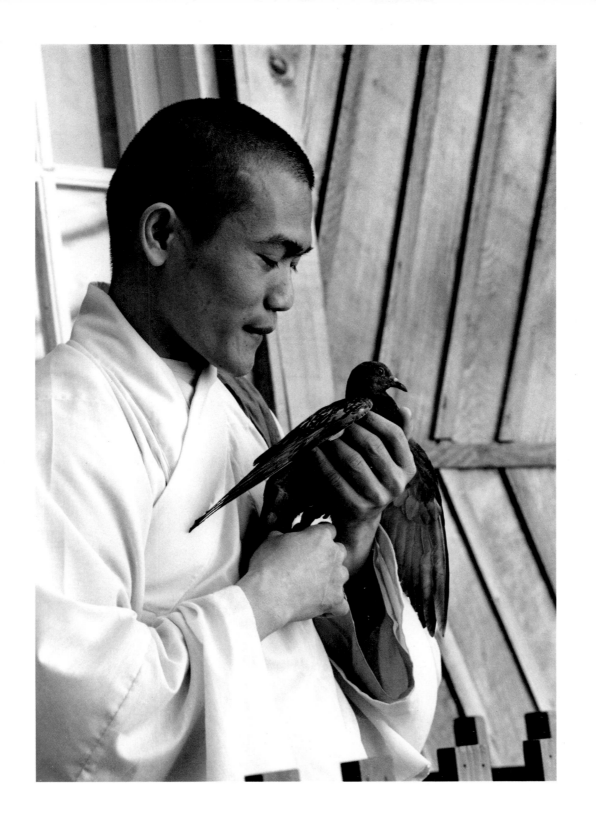

in 1978. Many people ask me why I became a monk, but I find it difficult to answer. I don't like to answer that because it is something sacred, a miracle. In Vietnam, I didn't go to the temple, I didn't know any monks and nuns. I didn't study Buddhism. I knew nothing about Buddhism in Vietnam. The miracle is now I have no hair, I wear a robe, and I love to practice Zen meditation. That is a miracle."

Five nuns live in the small, ochre-painted, wooden A-Di-Da temple. One of them, Thich Nu Dieu Ngoc, says, "I came here almost four years ago. We came here because we couldn't live under the communist government. I have gone through life and death to come here. The difficulty of our life here is the English language. We cannot speak about Buddhism with the American people, therefore we have to study English very hard."

"In Vietnam, the nuns often lived in the temple," she says, "but when we came here we had to go into society to live and work. It was difficult for us to do at the beginning, but now we feel more comfortable going to school and working here."

She had been an orphan adopted by Dr. Thien-An in Vietnam. "I loved him like a blood father," she says. But when she finally arrived in Los Angeles, she found that he had died just three weeks before. "It was very painful for me at the time," she explains, "but the Most Venerable Thich Man Giac helped me and taught me." She became a nun, she says, "because I want to live the life that the Buddha lived. This is difficult to explain because it is a feeling or experience in spirit."

It's a little later in the morning now. The traffic on Ninth Street is heavier, and the blades of the leaves of the tall, skinny palms that line the streets catch the light that filters through the gray metallic smog of Los Angeles. The smells

74

The late Dr. Thich Thien-An with Buddhist and American flags. During a workshop he conducted with an American psychologist exploring Gestalt and Buddhist therapy, he said the following: "Meditation is to master our minds so we can make a choice for ourselves. For example, when I am in contact with Nirvana in my mind then the world is Nirvana to me. And if I am in contact with Samsara, suffering world, then this world becomes suffering to me. Therefore, if I am wise, I will change the world into Nirvana, at least for myself."
Psychologist: "All right, so tell us how to do that."
Dr. Thien-An: "Laughter. When you laugh, you feel good, you feel happy, and then at that time you are in Nirvana, paradise. The man who knows how to laugh knows how to live and how to be happy. Sometimes when you are faced with a serious problem, laugh at yourself and at the problem."

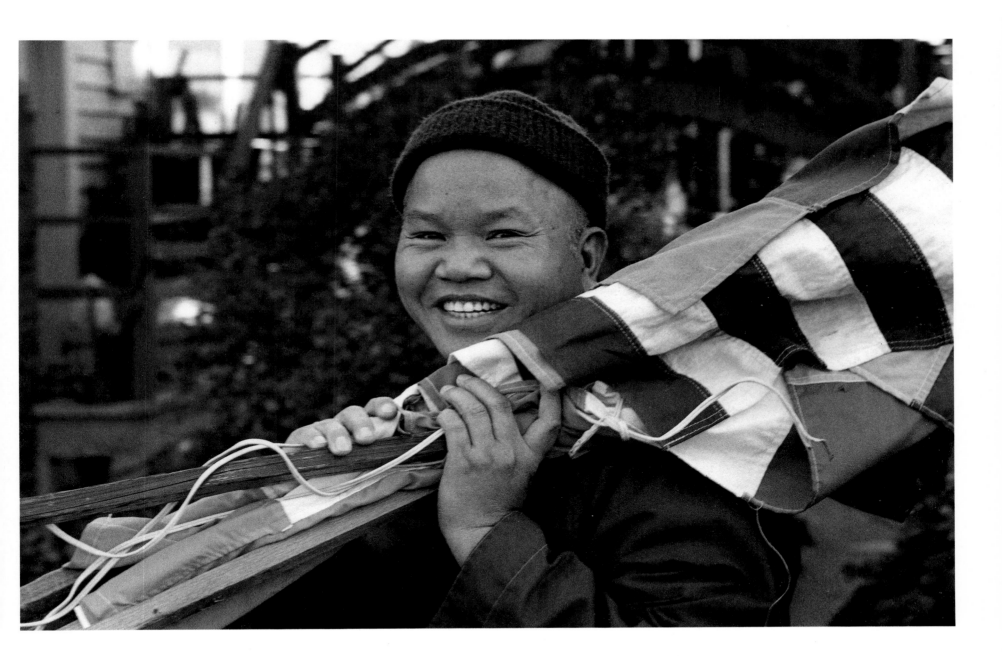

and sounds of cooking are coming from the kitchen, which is on the second floor of the temple.

The cooking, which starts with breakfast, goes on all morning and culminates in a traditional Vietnamese lunch for the monks and anyone who stays for the meal after the Sunday service. On some Sundays, if there is a special ceremony or holiday, hundreds of people will be fed from a small kitchen with no blenders or other evidences of American technological kitchen art—just endless processions of big pots and pans and piles of vegetables being neatly cut to size and shape, sizzling and steaming.

The disciplined domesticity of the women forms a counterpart to the relaxed discipline of the monks' lives at the temple. For the women, the temple is the center of the ancestral hearth, the old way of life that has gone on for thousands of years—the way of life that is itself the continuity of life. Somehow, even in the midst of war and prison and torture, of sons and daughters and grandchildren being killed by bombs falling from the sky or by the earth blowing up, it is the life that will go on, even here, in a country whose language and ways many of the elders will not have time to learn.

Mrs. Tran Thi Nhan has been coming to the temple nearly every Sunday since 1975. "This was the first temple I came to in the U.S.," she says. "I like and respect all the monks, and I feel the temple is precious for my life. I consider myself a good Buddhist. A good Buddhist always respects the monks and loves the temple. I'm a vegetarian ten days a month. I believe the most in Quan-Am and Thich-Ca-Mau-Ni-Phat (Sakyamuni Buddha). I also believe in all the other Buddhas and bodhisattvas. It's like a family here. Everybody is sisters and brothers."

And by ten in the morning, when all the children have arrived, it does indeed seem as if everybody is sisters and broth-

76

The game known as Nhay Day *has many variations, but in this case, the idea is to jump and get one foot over an elastic cord that gets progressively higher after each successful jump. In Vietnam, they make the cord out of many rubber bands looped together. Instead of playing gambling games for money, the children gamble for the much sought after rubber bands. In America, however, where elastic cords are inexpensive, rubber bands are rarely used.*

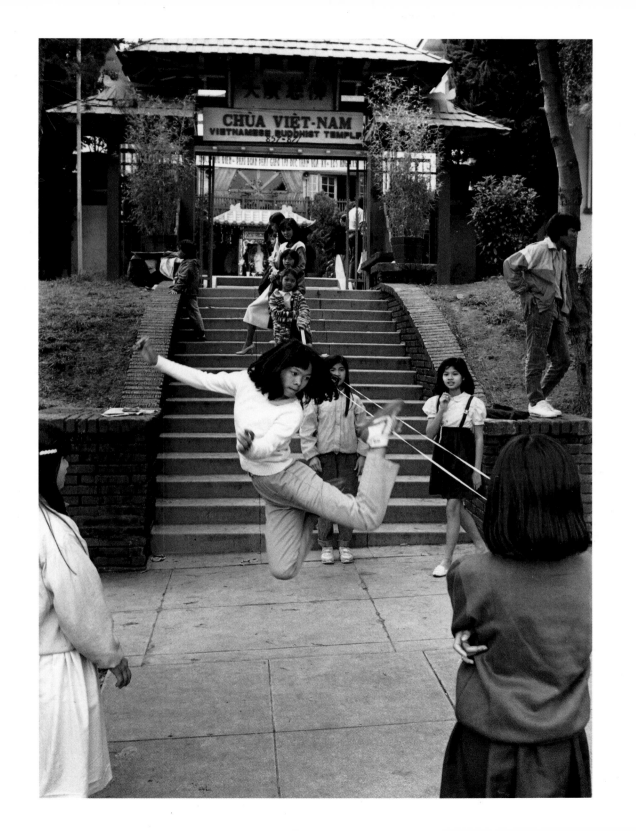

ers—or at least cousins and nephews and uncles and aunts and grandparents and great-grandparents. Living in Vietnam was to a large extent like living in one large extended family. Living in America is not like that, and the greater the assimilation, it seems, the less the ties of family bind and hold. In Vietnam, generations lived together. Here, married couples want their own apartments, and children strike out on their own sooner than they ever would have thought of doing in Vietnam. The temple, at least on Sunday, provides a place where the extended family is once more the way things are—rather than the way things were.

The children are wonderfully and unself-consciously at home in the temple. The littlest ones follow their parents around. They bow to the Buddha when their parents do, without, it seems, thinking too much about it. In this they are good Zen Buddhists—they are "just bowing," they are just offering incense with no ulterior motives.

Most of the children who come to the temple are members of the Buddhist youth group Long Hoa, which is modeled after the Boy Scouts (except that both boys and girls belong). Long Hoa was formed in Vietnam during the 1940s. Today, there are more than fifty-six such groups at the Vietnamese temples in the United States. Long Hoa represents the hope that the Vietnamese have for their children and the future.

The Vietnamese associate Long Hoa with Maitreya Buddha. Maitreya Buddha is the future Buddha, the next Buddha, the Buddha-to-come. The main characteristic of Maitreya Buddha is said to be loving-kindness and peacefulness, and his coming is believed to signify a new era of peace and happiness. "When the new Buddha comes," explains Nguyen Hanh, who is an adviser to Long Hoa, "he will bring a happy time, the world will have peace. It's a hope for the future. Long Hoa is that day. It unites our people together."

78

The game called Ooh *being played in front of the temple. While making the sound "ooh" with one breath, a boy crossed over a line and tried to tag as many kids as possible from the other team. Those who were tagged were allowed to hold him from getting back to his side. He didn't make it back still saying "ooh" with one breath, so he went to "jail" and it became the other team's turn. If he had gotten back still saying "ooh," everyone he tagged would have gone to jail and everyone from his team who was in jail would have been freed to come back to their side. A team wins when everyone on the other side has been tagged and is in jail.*

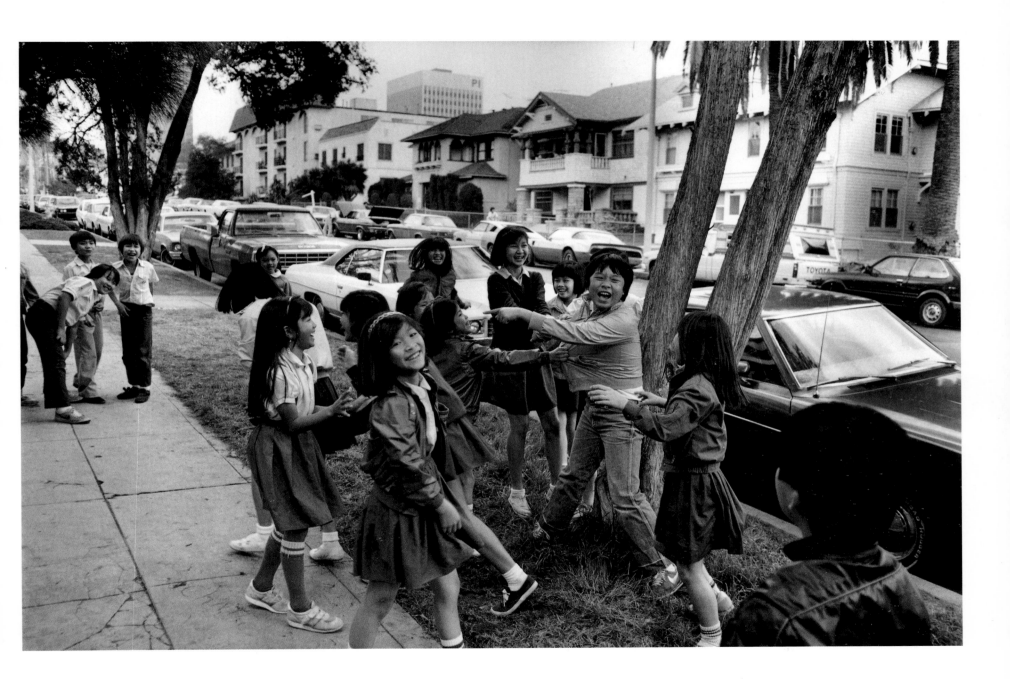

The members of Long Hoa—one might call them the Future Buddhas of America—wear blue jeans and gray Scout shirts with the emblem of Long Hoa, a green lotus on a white circle, as well as various other badges and decorations. The gray color of the uniform, says Nguyen Hanh, signifies the smoke from the hearth. "When we cook in our country, when we see smoke coming out of the chimney, we feel warm," he says. "That's why we wear this color. We want to be close to people." As a leader, he also wears a broad-brimmed Ranger hat, and a large silver whistle on a cord around his neck. The whistle has a high, soft, fluty sound like a bird's distant warble, and is used, more or less successfully, to get the group's attention.

The whistle is used with a certain abandon and adds to the generally mellifluous blend of the sounds of the temple on a Sunday. It mixes pleasantly with the shouts and laughter of the children lining up in ranks according to age in the central courtyard.

During the long years of war, the organization was active in social service. Nguyen Hanh, who now works with a refugee-settlement program run by the Catholic Church in Los Angeles, joined Long Hoa in Vietnam in 1956. "In town, we cleaned streets and picked up litter," he remembers. "We helped during floods and fires. There were youth groups—which we called 'families'—in each temple, in each town, in the city and the country. The 'family' would help people after their houses were bombed. We would help them build temporary structures, we would help carry the wounded to clinics. We call it a 'family' because we are just like a family. We love each other. When I came to the U.S., I lost my feeling of happiness, the feeling I felt with my family in Vietnam, in school. Everyday it was like here on Sunday."

After the kids assemble in the courtyard, with banners at

"Before I started coming to the temple," says Mykim, "I hardly spoke Vietnamese. I learned how to read and write and all the traditions and customs. I learned these things at the temple. I didn't know how important it is. I have friends who are 'Americanized' and they don't know about the fun holidays. I tell them, why don't you come to the temple."

the head of each column, they troop up the stairs to the main shrine room, where they hold their own service. They chant and bow, and they ring the bells. They sing "Namo . . . ," which is Sanskrit for "Hail to . . . ," and then the names of all the Buddhas and bodhisattvas, which most of them know by heart. Then they sing, in Vietnamese, "I take refuge in the Buddha. . . ."

There is never just one thing going on at the temple on Sunday. While the kids are chanting in the main shrine room, one of the women who has been cooking since early morning comes out to the memorial shrine, which is adjacent to the arm of the main shrine, and places elaborate offerings of food there. She is not a nun, though her hair is cropped as short as a nun's and she wears brown robes and, around her neck, a large mala (rosary). She is simply a devout Buddhist woman who lives more or less as a nun, now that her family has grown. She places big bowls of beautifully prepared vegetables, delicate spring rolls, and spicy tofu dishes on the side shrine, along with heaps of oranges and other fruit. The food is fresh from the kitchen, and the delicious smells waft into the main shrine room and mix with the fragrance of the incense that has been lit.

Meanwhile, another woman, wearing the traditional long, brightly colored tunic over loose white silk pants, is kneeling in front of the figure of Quan-Am. She is holding a round container filled with flat sticks like the tongue depressors used by doctors. Each stick has a Chinese character written on it, and she is shaking the container in a rhythmic pattern, her eyes closed in concentration. When one stick falls—or jumps?—out of the box, she takes it to one of the monks, who then gives her a piece of paper explaining the significance of the Chinese character. This "fortune telling," which is also prevalent in Chinese Buddhist temples, is not, strictly

"Vietnamese children tend to be shy," says the monk Thich Minh Dao. "These games where they act in silly ways in front of others, making embarrassing movements, teaches them to be fearless. The older members create games to help the children become quick-witted, nimble. They begin the games very slowly and then they play faster and faster. These are just simple games, but what they learn from them is helpful when they go camping and practice survival skills."

82

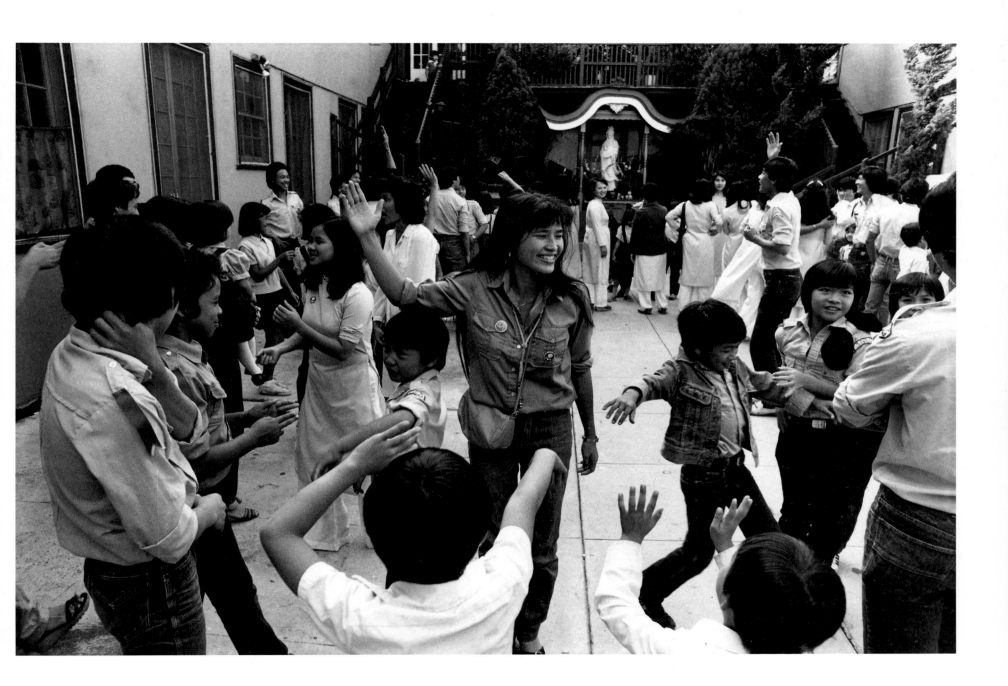

speaking, a Buddhist practice. Some of the monks accept it as a legitimate service the temple provides for the laypeople; others consider it mere superstition. It's something like checking the day's horoscope or throwing the I Ching.

When the service is over for the youth group, they reassemble in the courtyard with whistles and chants—more like cheers at a football game than the Buddhist chanting they've just finished—and divide into two groups. The youngest go off to a library classroom on the second floor, while the others go to a classroom on the ground floor, just off the courtyard.

The younger kids in Long Hoa, who sit at tables according to age, are studying Vietnamese. Even if they have grown up speaking Vietnamese at home, they usually cannot read or write it. Though monks learn the Chinese characters in which much of Buddhist literature is written, Vietnamese writing now uses the romanized script with special diacritical marks for the various tones that was introduced by a French missionary in the seventeenth century. Though originally developed to spread Catholicism and French culture, sutra books for Buddhist services are now written in this script.

Mrs. Tran My Nga teaches the class on Sunday mornings because, as she says, she is afraid that the children will lose their language. She herself has six children. When they're at school they learn English, she says, but when they come home she teaches them Vietnamese. Mrs. Tran My Nga uses Buddhist children's stories to teach the kids in class. Older children help out, checking the writing, leading songs. The younger kids happily chatter and work at various exercises. When things get too out of hand, the teacher blows her silver bird whistle or hits the table with a pencil. The approach seems to work. The kids at the temple are generally bilin-

"I want to teach what I've learned from my country because I know the young people won't have a chance to learn these things otherwise. In any civilization, there are good things to learn and bad things to avoid. I consider these dances and the other activities at the temple to be good things to learn from Vietnamese civilization. When I teach the children, I can see they feel good, they're joyful and they're proud."

Lan Huong

84

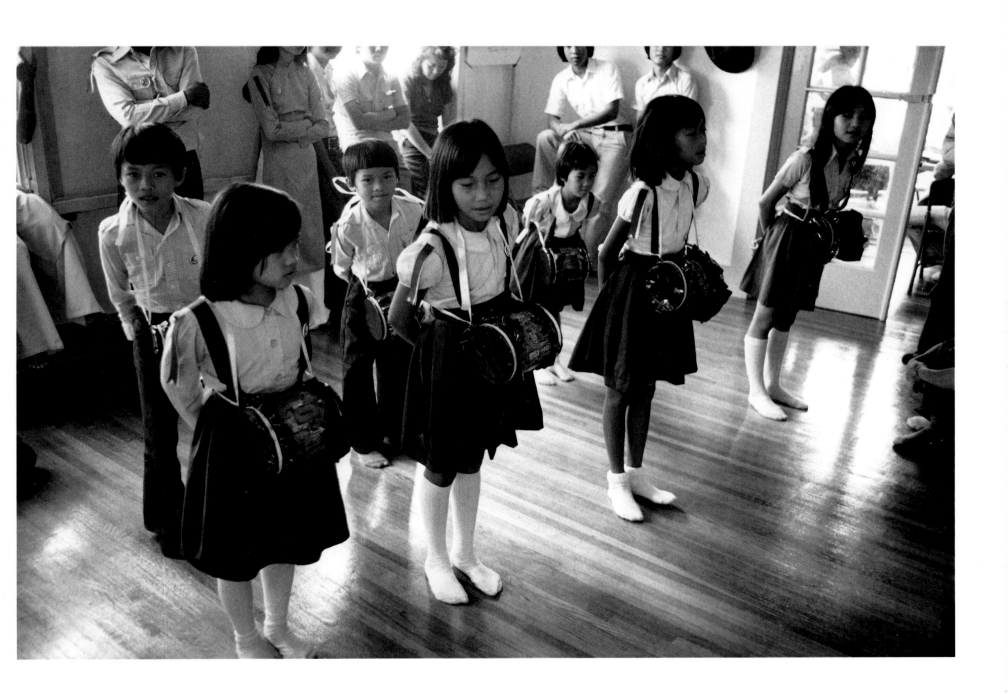

gual, and are able to move back and forth between the languages with ease.

The older children meanwhile are in their classroom across the courtyard. The group spends one weekend every summer camping, and they take their scouting skills seriously. A collection of snapshots in an anteroom, taken out in the field, attests to that. There is a tall signal tower constructed entirely of logs and rope, and a rope bridge spanning a canyon. There are photos of campfire scenes, of tents, and of scouts waving semaphore flags. A board shows the various semaphore positions; another holds examples of various knots and hitches.

Each Sunday one of the monks or laypersons gives a talk on Buddhism to Long Hoa.

"I talk with them about the teachings of the Buddha," says Thich Chon Thuan. "I explain the teachings and how to practice what Buddha taught in their own lives. An example is compassion. It means love. I teach them to love themselves, everyone around them, and nature. When they go out, they see one rose that's so beautiful. They can cut it, bring it home to their room, but only one person can admire the rose. If they don't cut the rose, the beauty and smell of the rose can be shared by many people. This is love. When you see a bird singing on a branch of a tree, the bird also wants to live in the world. If someone doesn't have compassion, he only thinks about himself and about killing the bird. This comes from selfishness and not respecting another life. The children understand, and they can open their heart to love animals, to love everybody, and nature. The basic thing I can teach them is to bring happiness to themselves and everybody and not to have harmful thoughts about others.

"The basic things they have to understand and apply in

On Sundays, Mrs. Tran My Nga teaches the children in the Long Hoa youth group to read and write Vietnamese because, she says, "I'm afraid they will lose their language."

86

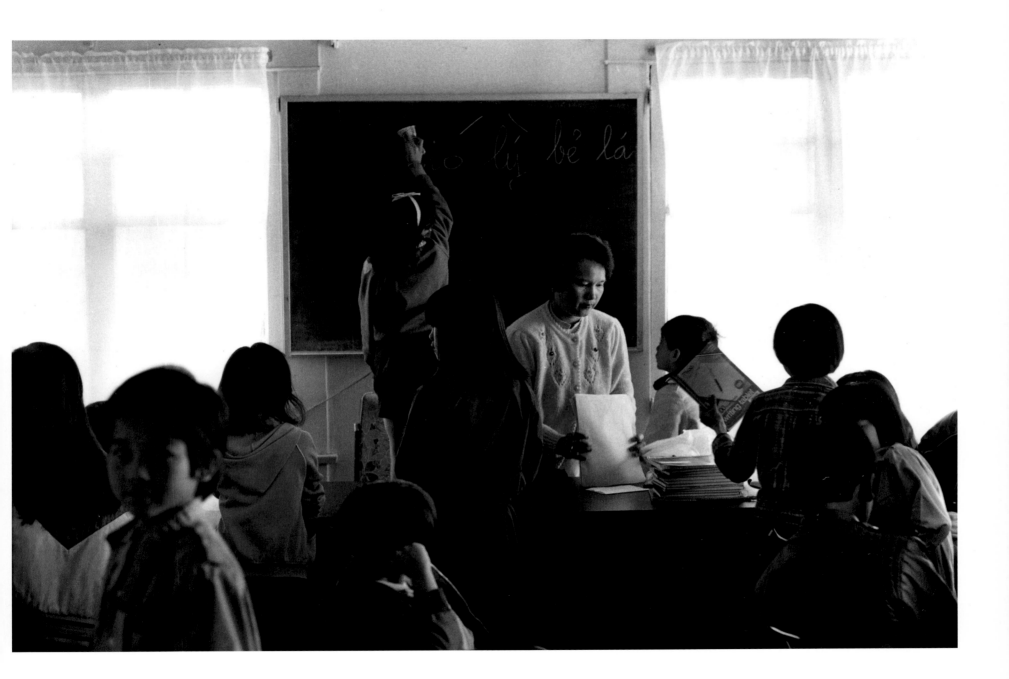

their lives are the six harmonies. The first harmony is to have a good relationship with everybody we are living with. Second is the harmony of speech, to not have disputes. Third is the harmony of mind. That is the common enjoyment of everyone. Fourth is the harmony of discipline. We all are trained to have self-discipline. Fifth is the harmony of advantage. There should be equality for everyone. Suppose I live in a group and someone gives me a cake. I don't keep it for myself. I can share it with everybody. Sixth is the harmony of point of view. Suppose I have a point of view. I can explain and discuss it with others with harmony. If everyone could understand and apply the six harmonies, we wouldn't have wars and the world would live in peace."

After class, the children and other young people of the temple assemble in the courtyard or on the street in front of the temple and get down to serious play. The games are mostly traditional Vietnamese children's games—a culture's continuity, after all, is carried on by children's games more than most adults might admit.

The games are both physical and verbal. As participants sit in a circle, a riddle or a phrase in a song is picked up and passed from person to person with subtle changes. Quickness, cleverness, and wit are all key elements.

At the same time, next to the sitting circle, another group of younger kids stands on the sidewalk with an elastic cord raised to shoulder height. The boys jump over the cord like high jumpers. A few of the girls do the same, but then one of them, smaller than the rest, cartwheels and gets one foot over the cord while upside down—a maneuver repeated by a number of girls who follow.

In another game, the kids must make embarassing movements and imitations. Their embarrassment is palpable but

88

"All my close friends come to the temple," says Mykim. "You do have friends at school, but they never know what you've been through. Here, everybody's in the same boat."

not painful. "Vietnamese children tend to be shy," explains Thich Minh Dao, a young monk who lives at a temple in Denver. "These games where they act in silly ways in front of others, making embarrassing movements, teach them to be fearless . . ."

For many of the older Vietnamese youth, particularly the girls, the activities of Long Hoa serve as a steadying influence, a counterweight to the confusing pressures of teenage life in Los Angeles. Many of the Vietnamese who attend Chua Viet-Nam are from Hue, the old traditional imperial capital, which was also a Buddhist center, and they tend to follow the old traditional ways. It is not unusual for a young Vietnamese woman of twenty or twenty-one to live at home with her parents and go to college but not go out on dates or to work. In this case, the activities of Long Hoa and the Sunday ceremonies at the temple are her main social activities.

Mykim is a seventeen-year-old Amer-Asian orphan. Her father, an American named O'Hara, is missing in action, and her mother died when she was one. "My grandparents were too poor to take care of me," she says, "so they sent me on weekends to the orphanage. The people at the program wanted to send me ahead to America because they knew South Vietnam would fall, but my grandparents didn't want me to separate from them. I know a lot of kids from the program who left and never saw their families again, and I know of many families who escaped later, in 1979, and they can't find their kids here. They put ads in the papers to try to find them."

She was six and a half when she arrived in North Dakota, and she was speaking English in two months. She moved to L.A. two years later.

"My grandmother got me started coming to the temple,"

90

The window modeled after the eight-spoked Dharma Wheel representing the 'Noble Eightfold Path' of Buddha: Right Understanding, Right Thought, Right Speech, Right Action, Right Livelihood, Right Effort, Right Mindfulness, Right Concentration.

she says. "Up in North Dakota, I was the only Oriental. I was completely Americanized. I didn't think I would like being with Vietnamese. I was really self-conscious. But I found you can be green in Long Hoa, as long as you speak Vietnamese. In Vietnam, there was prejudice against Amer-Asians, but in America the Vietnamese don't care.

Before I started coming to the temple, I hardly spoke Vietnamese," she says. "I learned how to read and write and all the traditions and customs. I learned these things at the temple. I didn't know how important it is. I wouldn't have learned about all the Vietnamese holidays. I have friends who are Americanized, and they don't know about the fun holidays. I tell them, 'Why don't you come to the temple.' Ninety to ninety-eight percent of the kids do come back at least once a year, especially on Tet (the Vietnamese New Year).

"Coming to the temple teaches you to respect how other people feel," she says, "instead of like in high school, where it's mostly making yourself feel good. You especially learn to respect how your elders feel. There's a lot more discipline, but it's not military here. It affects your moral judgment; it cuts away peer pressure. Now I think twice when friends say, 'Go ahead, try it.' I can say, 'No, it's against my standards.' There's a lot of willpower here. You learn how you can say no without feeling guilty. Out there, when you're eighteen, the parents kick you out. Here, it's like a clan. Everyone takes care of everyone. They teach you your parents have raised you and that you should want to help them when they get old. Generosity has a lot to do with this. In high school, they teach you how to be independent and ambitious, but here you learn that you have to share also.

"Once I wrote a report in school about what I'd been through," she says. "The entire school was in tears. I think it

"Zen practice is to discover the true self, the Buddha nature within ourself. Life is coming and going, life is up and down, life is living and dying, but that Buddha nature is always with us because it is true. It is the essence of living beings. We try to discover it by calming down the mind. Buddha himself did it. Through meditation he became enlightened. Bu means enlightened and dha means man. He was a man who became enlightened. Why not us?"

Thich Thien-An

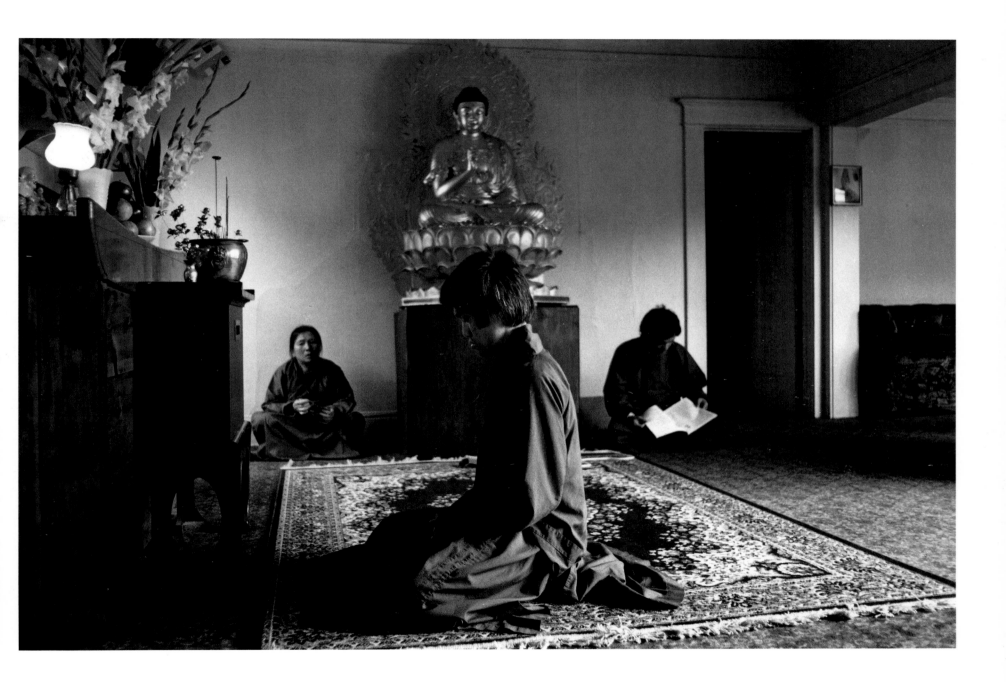

helped to make them think when they see an Asian face what they've been through to come here, to find freedom. Not only Asians, but Central Americans, Middle Easterners, or anyone from a war-torn country."

At noon, a monk slowly strikes the large bell in the main shrine room as a signal that the Sunday service is about to begin. By the time the bell ringing has ceased—the deep clear sound fading off into emptiness with a sweet, ever diminishing echo—the carpeted hall is filled with people sitting on the floor or kneeling. Children too young to be with the Buddhist youth group downstairs wander in and out.

Dr. Man Giac and nine monks in bright yellow robes enter and stand in front of the main shrine where there is a large seated Buddha with a painted backdrop. The painting is of the Bodhi Tree, which the Buddha sat beneath for the meditation that led to his enlightenment, and of the surrounding countryside—forests and mountains fading into the distance.

The main shrine is heaped with offerings. "People offer fruits and flowers to Buddha," explains Le Hau, a teacher who spent thirty years living in a monastery. "These are pure things. Buddha is Sakyamuni (the historical Buddha), but Buddha is also Buddha-nature in everybody, all living beings, animals, plants, rocks, everything. When I pray to Buddha, it also means that I pray to the Buddha-nature in myself. Buddha is perfect wisdom, great compassion, so I aspire for wisdom and compassion to grow in myself. That is the meaning of praying in the Buddhist tradition."

The sutras chanted during the Sunday service reflect the unified and nonsectarian range of Vietnamese Buddhism. As Dr. Thien-An wrote: "The Vietnamese Buddhist believes that all methods of practice and all doctrines in the Tripitika,

"There is a story in a sutra that someday there will be another Buddha, Di-Lac Buddha. There will be a celebration when the Buddha comes which will bring a happy time, the world will have peace. It's a hope for the future."

Nguyen Hanh

94

being taught by Buddha or by the patriarchs, are valuable and worthy of study; different practices and doctrinal systems are considered as skillful devices employed by Buddhas and patriarchs to lead all beings to enlightenment."

Thus Vietnamese Buddhists chant, among others, the *Saddharmpundarika* or *Lotus* Sutra, the *Avatamsaka* Sutra, the *Lankavatara* Sutra, and the *Vajracchedika* or *Diamond Cutter* Sutra. And as followers of Zen do everywhere—in China, Korea, and Japan—they pay particular homage to the *Heart* Sutra.

As followers of the Pure Land school, they chant also to Amitabha Buddha, A-Di-Da-Phat in Vietnamese ("A-Di-Da" is Amitabha; "Phat" is "Buddha"), the Buddha of boundless light and unceasing life, and to *Avalokitesvara*, or Quan-Am, the Bodhisattva of compassion.

"A-Di-Da Buddha is in us, not something distant but right here," says Jennie Hoang, who first came to the States in the 60's as a graduate student in French literature. "After we chant and greet the bodhisattvas, then we chant the attributes of A-Di-Da-Phat: unlimited light and life. I think, Oh, it's in me. I celebrate it. On another level, it can be something we chant to ask for help. A-Di-Da is not a personal thing. It's the source that dwells in the Pure Land."

"A-Di-Da-Phat is everywhere," says one monk. "You have it. A-Di-Da-Phat has much light, and is not born, not dying. You have it, I have it, everybody has it. It's like water. Everything has water in it—the chair, your arm. But unless you have Buddha eyes, you cannot see it.

"Quan-Am is inside of everybody," says the monk Thich Tanh Thien. "That is very important to know. When you are thinking of Quan-Am, Quan-Am is in you already. Also, even if you don't think about Quan-Am, Quan-Am is in you. When I talk to the laypeople, I teach that Quan-Am is every-

"You stand in front of Buddha, not to a statue, but to Buddha inside yourself. It's important to know that, otherwise you're bowing to a piece of wood or metal. When you look inward to the Buddha nature, you feel peace in your heart. You give thanks to Buddha because without his teachings, you would not have found this way of understanding and loving."

Thich Tanh Thien

96

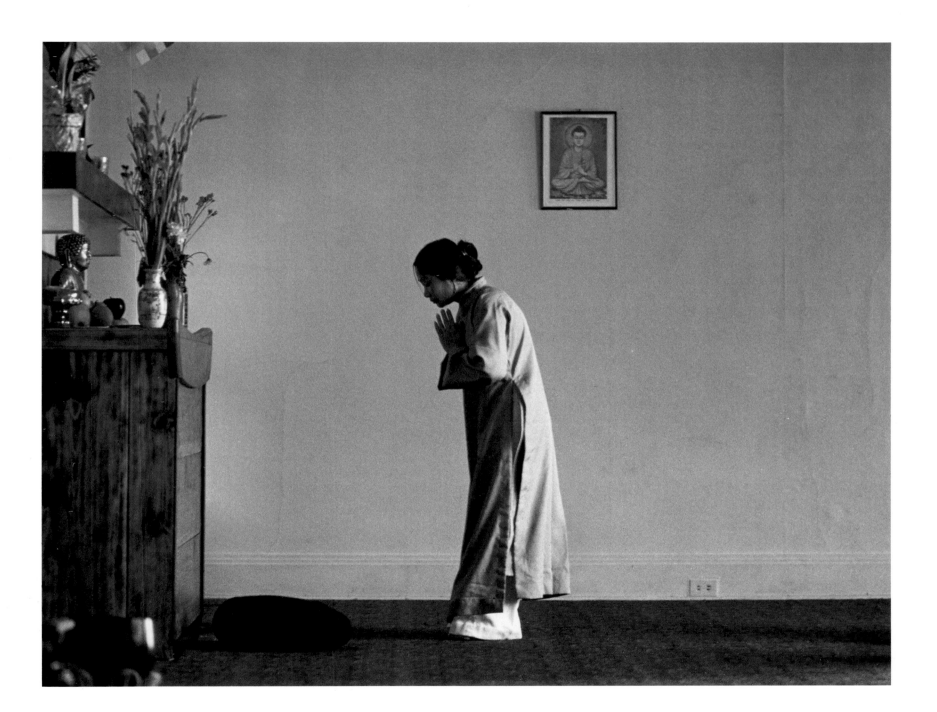

where. It's inside of them. In other words, they are Quan-Am. They can see that people are Quan-Am. That's Zen practice."

Memorial services for the dead are also a part of Sunday service. The relatives of the person who has died wear white headbands. They are given long, narrow strips of paper, with Chinese characters written on them, which they balance on their heads. Each mourner is also given a stick of incense to hold. A monk intones a text that refers specifically to the person who has died.

"Someone has a relative who has died," explains Le Hau. "They come to the temple to pray and chant. They believe that when they do that for dead people, the people can go on to a better world, a better situation. What a person will become depends on that person's actions when he lived on earth. He could become an animal, a man in heaven, or come back to this world. There is a stream of life. It does not end when you die. If you want to live in a better world, it depends on what you did in this life. There are infinite world realms."

At eight o'clock on Sunday mornings, Dr. Man Giac leads a class in Zen meditation. Members of the temple became inspired to include Zen practice in the temple's activities a few years ago during the visit of Thich Nhat Hanh, Dr. Man Giac's old friend, who is a Zen master and a poet and a spokesperson for engaged Buddhism. Thich Nhat Hanh is probably the best-known Vietnamese Buddhist in the West now, due to his books, a number of which have been published in English, and to his visits to the States to talk with American Buddhists about "engaged Buddhism." He has also, however, emphasized the practice of silent Zen meditation among the Vietnamese and conducted retreats for Vietnamese monks and nuns in America.

Dr. Man Giac and Thich Nhat Hanh are examples of the generation of Vietnamese monks whose lives were forged in the crucible of the Vietnam War. Their connection goes back a long way. Dr. Man Giac was head of a temple in Hue when Nhat Hanh sent him a letter, in 1952, inviting him to join him in Saigon.

"Nhat Hanh said, 'You're not going to wither away in that temple in Hue,'" Dr. Man Giac recalls. "In those days, to go from Hue to Saigon was like going abroad. Nhat Hanh at that time was a revolutionary, an outcast. When I was in Saigon, laypeople from Hue sent me money each month. Nhat Hanh and I and three other monks bought a little hut made of wire and paper. In it, we had a little altar and a Ping-Pong table. We were the first monks to go to public school. At that time, it was very revolutionary to see monks on bicycles, or going to public schools, or playing Ping-Pong. The government was watching us.

"We were very poor, and we enjoyed each other tremendously. We painted the newspaper, but with the hot weather it was crisp and brittle. There was a great danger of fire, but the community was watching, and the laypeople would bring us food. We would give them medicine and help the sick. One wealthy layperson gave us a big Zen gate, but it looked very funny with the wire-and-paper hut. I was the only person who knew all the rituals, and people recognized me as someone from Hue, and they brought me food and special gifts.

"The government thought we might be subversives being protected by the community, so because of security problems we had to leave Saigon. We went to Dailat, where Thich Nhat Hanh started a Zen meditation center. That period of seven years in Dailat was the golden age."

Sunday services at the temple are followed by lunch, which is served upstairs in the kitchen and dining room. (The children had been served in the courtyard while the service was going on.)

Each year, there is a three-month retreat or training period at the temple. This tradition has been passed down from the time of the Buddha, when the monks and nuns practiced in one place during the rainy season. The retreat, called Ango in Japanese and An Cu Kiet Ha in Vietnamese, begins on the Buddha's birthday, the day of the full moon in May. During this period, monks who live elsewhere return to the main temple to live and train together. In Vietnam, laypeople would prepare a ceremonial meal for the monks every day during this period. Here in America, the ceremonial meal is prepared by

the women of the temple every Sunday. The food is vegetarian and makes imaginative use of tofu and other forms of soy beans, sometimes imitating the taste of fish and chicken. The monks sit together at a long table, with Dr. Man Giac at the head. Before beginning the meal, the monks chant, "In accepting this meal, I vow to abstain from all evil, to cultivate all good, and to benefit all sentient beings."

Lunch is served as well every Sunday to anyone who is at the temple. It's an informal, social time. The vegetarian food is placed on long tables in little dishes. There are always pots of rice and soup and piles of paper-thin spring rolls. The food is elegant, light, and spicy, and there is always enough and often more than enough. Guests or strangers may find it hard to convince their hosts that they have truly eaten their fill.

After lunch, Dr. Man Giac is often to be found sitting in front of a coffee table in a room that serves also as a passage to the memorial shrine and the kitchen. It is here that he talks to people informally, discussing their problems and their spiritual practice and transacting the temple business. It all happens quite naturally and feels more like a big family get-together than what Westerners would think of as a religious gathering.

In that spirit, the day ends slowly. People help clean up after lunch, other people pause to bow and offer incense to the Buddha in the main shrine or to the memory of a relative or friend at the memorial shrine, or to cast the sticks before the image of Quan-Am. The children run in and out, and the old men and women gather and talk. In a back room of the temple, a group of men might gather for a more serious discussion involving refugee politics. As one Vietnamese told me, "If you see three Vietnamese together, you can see an organization or a committee."

By three in the afternoon, fewer and fewer people linger in the temple, in the courtyard, or on the steps down to the street.

In the office, which is in a room to the side of the main shrine, are an old desk, a few couches, and a bookcase with books in Vietnamese. The coffee table in front of the couches holds copies of Vietnamese Buddhist magazines and newspapers published in Los Angeles.

The secretary of the temple, Miss Trang, sits behind the desk, balancing the checking account and accepting ten- and fifteen-dollar donations that pay for the upkeep of the temple—"food and flowers," as she characterizes it.

Miss Trang was a librarian in Vietnam. Now she works for a bank. When she has saved some money, she sends packages of medicine and clothing to her relatives in Vietnam. The packages are sent through an expediting service in Chinatown. In Vietnam, the contents of the packages are often sold on the black market. The money is crucial to the well-being, sometimes even the survival, of the recipients. Because money cannot be sent to Vietnam, this is the only way to send relatives and friends currency.

It is part of Buddhist tradition for laypeople to support the monks and temple through donations as well as by cooking and providing other services. Giving is an important part of Buddhist practice. The first of the six *paramitas* (perfections), and the one that is said to necessarily precede all others, is *dana paramita*, or the perfection of giving. To truly give—to give perfectly—it is said that one should give without thought of return and without making a distinction between giver and receiver. In the perfection of giving, of *dana*, everything, including the merit of giving, is given away.

The Vietnamese are open and generous in their giving. There is a wooden box with a slot for money beneath the Quan-Am in the temple courtyard, and other boxes are in the main shrine room. A chart on the wall lists names and the amounts of monthly pledges. Next to that, another chart lists the amounts and the names of people who have contributed to Lam-ty-ni, which is Vietnamese for Lumbini, the birthplace of the Buddha.

Lumbini is now in Nepal, and the Vietnamese Buddhists' support for this project is another sign of their faith and far-seeing internationalism. The Lumbini Project, which involves restoring the Buddha's birthplace as a pilgrimage site for all Buddhists as well as building a world peace center there, was first envisioned by U Thant, the Thai Buddhist secretary general of the United Nations. The United States Lumbini Committee has drawn American Buddhists of all schools together in a common project, and the Vietnamese Buddhists, though among the poorest and most recent of American Buddhists, have

been among the strongest supporters of this project.

Sunday at Chua Viet-Nam ends, as every day ends, when a novice monk chants in the evening while ringing the large bell and then striking the *mokyo*, a wooden percussive instrument shaped like a fish. He is chanting for the hungry ghosts, the *pretas*, which in Buddhist cosmology are lost souls, ever hungry, ever thirsty, wandering like cosmic refugees driven by hunger and thirst through the universe. They, too, must be treated with compassion and fed with the food and drink of liberation. It is not hard to imagine them flickering through the soft twilight of a summer's evening in Los Angeles to the warm glow of the temple, and to the offerings of a bowl of soup made of rice and water, and to the stick of incense burning like a tiny beacon which the novice monk places on the balcony of the temple as an offering in the vast, darkening sky of Los Angeles.

Buddha's Birthday

Vietnamese Buddhists celebrate three major holidays every year—the Vu-Lan festival, which marks the end of the annual three-month retreat for monks and nuns; Tet, the Vietnamese New Year; and the Buddha's birthday.

The Vu-Lan festival is celebrated in August, when the monks and nuns who participated in the retreat offer all the spiritual merit earned through their practice to their parents and the parents of others, and offer prayers for all the beings suffering in the lower realms of the hells, hungry ghosts, and animals. They also accept offerings of food and other gifts from the laypeople.

Tet is celebrated according to the lunar calendar, usually around early February. Tet is a night time celebration, and during it the temple courtyard in Los Angeles is filled with people and fireworks. The fireworks are such an important part of the Tet celebration that each year the temple receives special dispensation for them from the fire department.

The Buddha's birthday is a daytime spring celebration, observed each year on the Sunday closest to the

full moon in May. It is a holiday observed by Buddhists throughout the world, though the exact date may differ from country to country. It is a festive time, a time for children and their parents to come together with the whole Buddhist community. There are always flowers everywhere on the Buddha's birthday.

On this particular Sunday in May 1986, the 2,530th year since the birth of the Buddha, the Buddha's birthday is being celebrated in a big way. The Vietnamese Buddhist community seems to have the sense that it has come through, that it has once more survived a difficult time against great odds, and that, though the future is uncertain and even perilous, there is much to be thankful for.

A large green parachute has been spread from roof to roof over the central courtyard. Beneath this soft, translucent shelter, the Vietnamese community and guests and friends are gathered. There is a large wooden platform in front. The Buddhist flag with its orange, white, red, yellow, and blue stripes is strung along the rooftops, and in the hands of nearly everyone there. It is a bright, happy sort of flag—the same flag that Diem had forbidden the Buddhists of Hue to fly back in 1963.

The image of the Buddha stands against an immense backdrop behind the platform, with the words "All Buddhists Happily Celebrate Buddha's Birthday," in English and Vietnamese. The Buddha is standing with one hand pointing up toward the sky and the other pointing down toward the earth, and looking straight ahead.

This year's celebration coincides with the United Nations International Year of Peace, and there is a representative from the U.N., as well as other dignitaries, representatives of the mayor's and governor's offices, and monks and nuns from other Buddhist traditions who now make their homes in Los Angeles and elsewhere in the United States. There are also a fair number of American Buddhists representing newer Buddhist groups.

There is no question that this is a Vietnamese celebration, but there is also no question that many others are included in it. This is due in no small part to the vision of the Most Venerable Thich Man Giac—the realization that in order for Buddhism to flourish in America, whether among Vietnamese or Amer-

icans or Vietnamese Americans, for that matter, it must adapt to its new home. "The customs of Americans are different from those of Asians," he says. "If we want Buddhism to develop and grow in the U.S., we must adapt to American customs."

Whatever the future may hold, today is a day to celebrate the continuing strength and resilience of the Vietnamese Buddhist traditions. The women have been cooking for days. Flowers and flags and balloons with the legend "Happy Birthday" are everywhere, particularly in the hands of toddlers bouncing around under the watchful eyes of slightly older brothers and sisters.

There are greetings and speeches from the platform, and there is chanting in praise of the Buddha in many of the languages of Buddhism—in Vietnamese, Korean, Japanese, Pali, and Sanskrit, and also in English. The president of the organizing committee of the celebration, Dr. Nguyen Thang Thai—a scholarly layman wearing a round black traditional hat that seems all brim—sums it all up when he says, "What happened in Vietnam—the misery and sorrow—has no end, but I want to make a solemn vow for peace and freedom in Vietnam." As is the custom on many Buddhist holidays, a number of pigeons are released, and then, as is the custom on this particular day, some people file past a small figure of the Buddha and pour water over the image with a small ladle.

Berendo Street has been closed, or at least slowed down, by two motorcycle police, and the main concern is how to start and maneuver the float that is the centerpiece of the parade. The only way for the man driving to see out is through a few small holes bored in the flower-festooned wood panel that covers the front of the truck. The whole float is also covered with flowers. There is a large pink, white, red, yellow, and blue paper heart on one side framed by flowers, and on the other side is the Eight-spoked Wheel. Its spokes are made of flowers—red, orange, pale green, and pink, with blue in the center. On top of the float the Buddha stands, with the backdrop of India looking very blue and green and Himalayan cool in the Los Angeles heat. There are live trees on top of the float, too, with beautifully made orange and yellow paper flowers fixed in their leaves. Paper dragons with benevolent toothy smiles guard each side. Someone mentions that the monk in charge of getting the float ready hardly slept in a month. Someone else

sprays water on the real flowers, which are in danger of wilting in the heat.

Finally, the Buddha's float begins to move slowly away from the curb toward the center of the street. There, four young girls wearing traditional Vietnamese clothes and with floral wreaths in their hair climb on top and take positions on the float.

First come two men holding a large banner that reads: "950 Million Buddhists All Over the World Happily Celebrate the Buddha's Birthday."

Then come four men, wearing traditional black robes, carrying an American flag, a Buddhist flag, the flag of the United Nations, and the yellow-and-red-striped flag of South Vietnam.

Then comes the Most Venerable Thich Man Giac, Supreme Abbot of Vietnamese Buddhists in America, wearing a bright yellow robe, a red transparent overrobe flecked with gold thread, and a high peaked hat. He is followed by four members of Long Hoa bearing a palanquin with a large incense burner. They are followed by more members of Long Hoa bearing flags from all over the world, and the green banners of Long Hoa, and by kids with lots of balloons.

Then a Vietnamese brass band, the players in dark trousers and white shirts.

Then the float with the Buddha and the four girls, moving slowly and carefully, guided by members of Long Hoa.

Then an oil painting of the Venerable Thich Quang-Duc—the first monk to immolate himself—his robes in flames, held aloft on a palanquin by four young men.

Then the banners, in various languages.

"There Is No Religious Freedom in Vietnam."

"Long Live the Sacrificial Spirit of the Venerable Thich Quang-Duc."

"Long Live World Buddhism."

"Unity Is Strength."

And, finally, "950 Million Buddhists All Over the World Unite with Other Religions to Serve World Peace."

The rear is taken up by dancers twisting and swirling around a two-man dragon to drums, cymbals, and gongs.

The parade goes up the street and pauses before the nun's A-Di-Da temple and the International Buddhist Meditation Center. At each place, Thich Man Giac and the other monks chant and offer incense. At the Center, they are greeted by a banner: "Government in Vietnam Has to Give Freedom Back to Monks, Nuns, Buddhists, and Prisoners of War."

After circling the block, the parade returns to the temple. There, as on every Sunday, everybody is fed, though today there are so many people that most take their paper plates out to the courtyard or the street below. A woman is singing Vietnamese popular songs through a microphone in the courtyard now, and the kids are playing and the old men and women are exchanging gossip. And I don't think that I was the only one who noticed that the doves that had been set free that day had nearly all decided to stay and take refuge in the temple of Chua Viet-Nam.

Acknowledgments

Permission to quote portions from *Buddhism and Zen in Vietnam* by Thich Thien-An, Rutland, Vermont: Charles E. Tuttle Co., 1975; *Vietnam, Lotus in a Sea of Fire* by Thich Nhat Hanh, New York: Hill and Wang, Inc., 1967; and *The New Face of Buddha* by Jerrold Shecter, New York; Coward McCann, 1967, is gratefully acknowledged.

We have also referred to and made use of brief quotations from *Vietnam, A History* by Stanley Karnow, New York: Viking Press, 1983; *Fire in the Lake* by Frances Fitzgerald, New York: Vintage Books, 1972; *Zen Philosophy, Zen Practice* by Thich Thien-An, Berkeley, Calif.: Dharma Publishing, 1975; *The Raft Is Not the Shore* by Thich Nhat Hanh and Daniel Berrigan, Boston: Beacon Press, 1976; *The Unified Buddhist Church of Vietnam* by James H. Forest, Amsterdam, The Netherlands: International Fellowship of Reconciliation, 1978; and a paper titled "Buddhism and Political Power in Vietnam" by the Most Venerable Thich Man Giac, which was delivered at Gettysburg College, April 16, 1986.

Finally, we would like to acknowledge the generosity of the Sangha—the community of monks and nuns and lay men and women and children—of Chua Vietnam who all patiently and cheerfully gave us so much of their time for interviews and background information. This is their book.

Don Farber studied photography at Manchester College of Art and Design in England and is a graduate of the San Francisco Art Institute. His work has been shown in a number of museums including the San Francisco Museum of Modern Art, and he received a grant from the California Arts Council. Nearly every Sunday for ten years, beginning in 1977, he went to the Vietnamese Buddhist Temple in Los Angeles to photograph, participate in the life of the temple, and interview members of the community.

Rick Fields attended Harvard College. He is the author of *How the Swans Came to the Lake, A Narrative History of Buddhism in America*, co-author of *Chop Wood, Carry Water*, and editor-in-chief of *The Vajradhatu Sun*, an international Buddhist newspaper published in Boulder, Colorado.

Thich Nhat Hanh is a Vietnamese Zen Master, poet, and peace activist. He is the author of *The Miracle of Mindfulness, Lotus in a Sea of Fire, Being Peace*, and many other books. He was nominated for the Nobel Peace Prize by Dr. Martin Luther King, Jr.

Aperture Foundation, Inc. publishes a periodical, books, and portfolios of fine photography to communicate with serious photographers and creative people everywhere. A complete catalog is available upon request. Address: Aperture, 20 East 23 Street, New York City, New York 10010.